# ROMEO

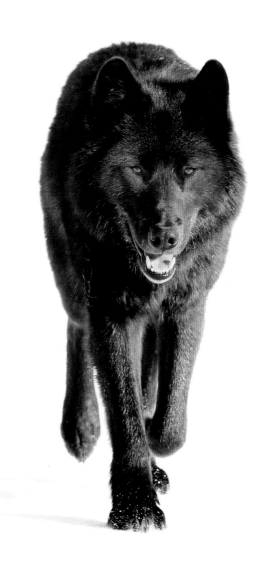

# ROMEO
## THE STORY OF AN ALASKAN WOLF

john hyde

BUNKER HILL PUBLISHING

www.bunkerhillpublishing.com

First published in hardcover 2010
This paperback edition published in 2012
by Bunker Hill Publishing Inc.
285 River Road, Piermont
New Hampshire 03779, USA

10 9 8 7 6 5 4 3 2 1

Library of Congress Control Number: 2010931626

ISBN 978-1-59373-106-9

Published in the United States by Bunker Hill Publishing
Designed by Peter Holm, Sterling Hill Productions
Printed in China

For Romeo and for my wife Barbara and my daughter
Jenna who both supported my efforts and did not
begrudge me the time I spent with my furry friend.

# PREFACE

The first time I met Romeo face to face, close enough that we could stare into each other's eyes, I felt I was sitting the edge of two worlds: one so wild and free I might never be able to comprehend its true significance, the other civilized, which I was driven to escape from on a regular basis.

Romeo's loving, playful soul was what so many people found endearing, and it drew me as well. But in his gaze my sense of reality seemed warped, the space between us undefined—as if we were at once brothers, yet at the same time alien. But if friendship can be defined as a relationship primarily based on respect and trust, then friends we were.

The impact of our species on Romeo's world shaped his particular fate. He did not ask to be left an orphan on the edge of a land inhabited by humans. But he made do with what he had. His innate drive to socialize with others of his own kind also drew him to those who could satisfy that need: the dogs who shared his territory in the upper Mendenhall Valley. It was his wonderful spirit that made it possible to survive in that environment as a wild wolf on the edge of a domesticated world. It was his kind and playful spirit that drew our kind to him and that in turn changed many people's perception of wolves. The relationships he developed with his many canine friends (and their owners as well) became a force that enabled him to coexist in a place and in a way that few, if any, wolves ever had before. These experiences opened the minds of many a human—and not the least my own.

Thus, this book is in many ways a thank you to all those who honored, respected, and even grew to love this wild wolf who just wanted to have some fun—especially all the people who helped *others* to understand him and what he stood for, and who helped in any way to keep him safe.

Many differing opinions developed concerning the best way to achieve this understanding and safety. Resource managers, wildlife enthusiasts, dog walkers, tour operators, recreational users, hunters, trappers, and photographers all had their own ideas of what was "best" for Romeo, and many disputes resulted from these different opinions.

Ultimately, everyone who worked to help others understand Romeo and did whatever they thought was best for him deserve credit. In the end, they all promoted a better understanding and appreciation for the needs of wolves and the idea that we—humans and wolves—can live together not as competitors, but as neighbors. We humans need only be willing to make small sacrifices and respect the needs and rights of wild animals to use the same natural resources we do.

If Romeo wished to leave behind one legacy, that would have been it: that he was proof that we can live together. We can look beyond our differences and work together for the common good, which is nothing less than the preservation of life and our planet.

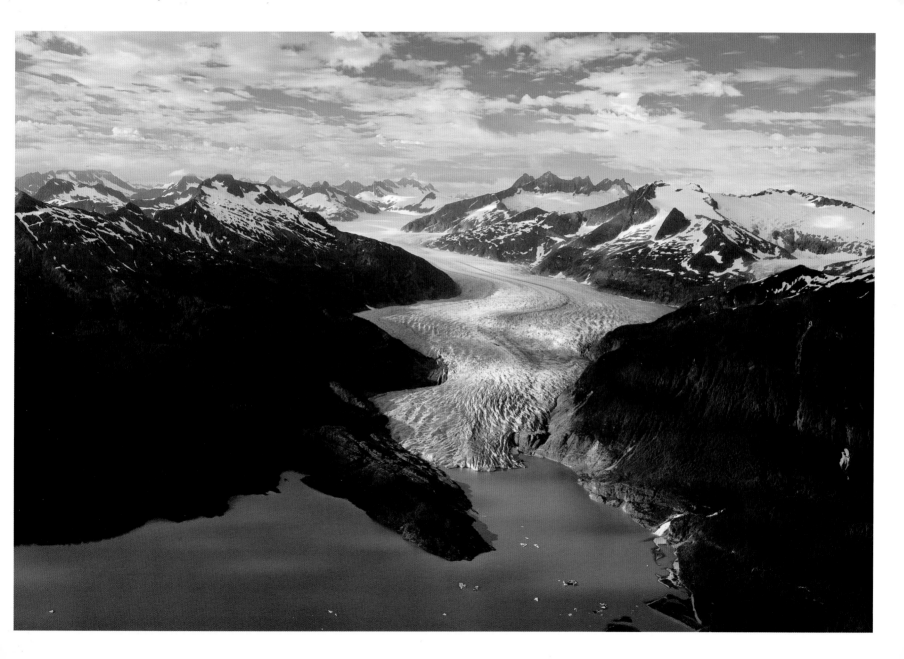

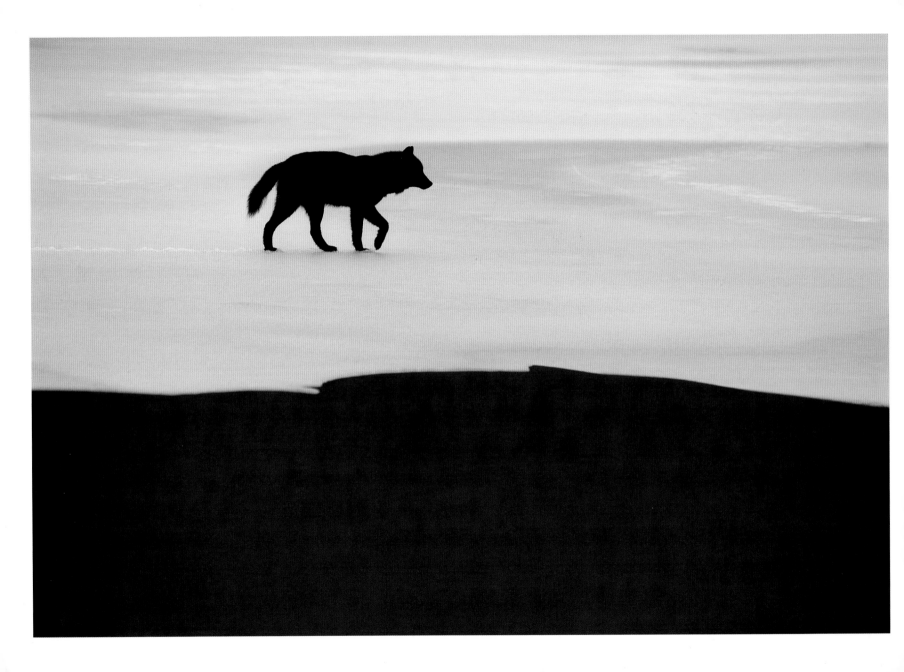

## WHAT MUST HAVE HAPPENED

Light snow was beginning to make its way down through the dense forest, falling from a gray winter sky. A female and her one-year-old pup were exploring the south side of Nugget Creek when a harsh cry clove the silence and made them crouch and shiver in their tracks. Seconds later there was another howl, followed by a third. The whisper-quiet stillness of the morning was now transformed into a chaos of whines, cries, howls, and barks announcing that some terrible fate had befallen other members of their pack.

Dashing across the small stream that separated them from the others, splashing and slipping on the wet, ice-covered rocks, they rushed up the bank and through the brush into the open-canopied forest beyond.

A harsh bark and agonized stare of bewilderment stopped them in their tracks. The leader of the pack, the alpha male, was warning them not to come any closer, staring at them with intense pain and sorrow in his eyes. Taking in the scene with quick glances all around, the female and pup tried to absorb what was the most disturbing scene they had ever witnessed. Almost the entire pack had been caught in some kind of terrible constricting agony. The freedom they had come to view as simply a right of existence was over. Instead they found themselves tethered to the forest floor or to surrounding trees. The scent of blood permeated the air. With crushed bones and torn flesh, those caught in the traps agonized over how to escape. The pair stared at the scene.

The alpha male implored them not to approach any closer but the drive to help was overwhelming. Approaching one step at a time they inched their way forward. The two leaders—the alpha or

breeding male and the female—touched noses in a tender but anxious greeting.

The pup approached one of the other members, a two-year-old female who had often cared for him when his mother and father were busy with the responsibilities that leadership brought. Cowering on the ground, she licked at her wounds and looked up at him with eyes that had already lost their spark. The wounds to her soul were worse than those to her foreleg, which was crushed between what looked like the toothy jaws of another large carnivore. As the young wolf stood there, rooted to the ground in bewilderment, a cry of anguish drew him around the base of a huge tree where he found his sister trying to break free from whatever was anchoring the trap that held her foreleg to the forest floor. She had already broken a few teeth on the forged steel and wasn't making any progress. He rushed in, trying to free her from its binding strength but simply couldn't help.

Only two other members of the pack had escaped. One of them had had to give up three toes to break free from the steel that gripped them. She had reacted quickly to the touch of the cold metal pan of the trap, but not quickly enough. The other, a three-year-old male who'd come up in the ranks about as far as he could, had been hunting over by the base of the ridge and thus escaped injury.

The female who was now minus a few toes had been in estrus (heat) twice now but had not been allowed to breed because she lacked the status of an alpha female. The male had been feeling "the call of the wild" for months, so it was just natural that they melted away into the forest, heading out as the leaders of a new pack. These two wolves, having struck out on their own, left the young male and his mother behind with the others. The bond they had with the alpha male and the rest of the pack was too strong to abandon them.

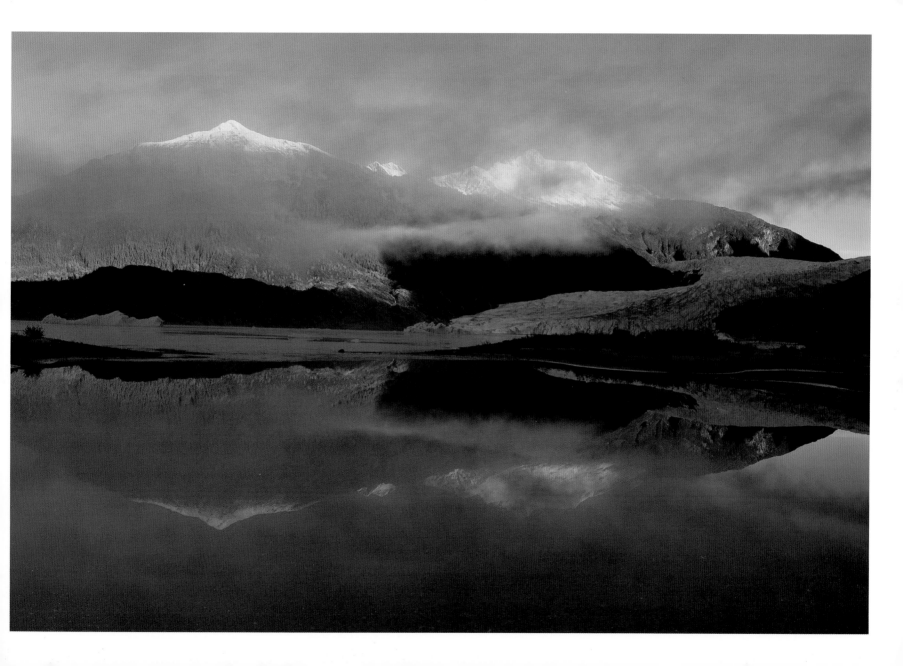

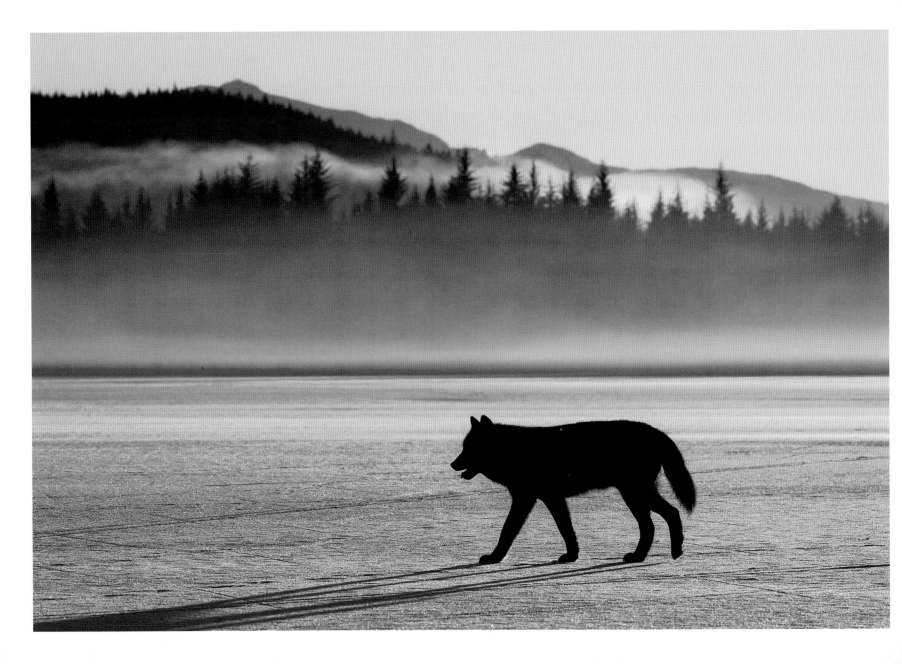

For the rest, relief from the traps would only come with death from their injuries or starvation, or from a trapper's bullet to the head.

After a few days of anxious waiting, the alpha female and her pup had to leave and find something to eat. Their raging metabolism demanded it, so they headed back upstream and out along the ridge above. Following a familiar scent along the base of a steep cliff near the tree line, the two soon found the carcass of a young mountain goat. The goat must have slipped and fallen on its way down to find shelter among the trees from the late-winter storm that raged earlier that week. It wasn't yet completely frozen, so they made good use of the nourishment it provided. Over the next 24 hours, they reduced the carcass to bones and hide, then headed back down to check on the others. When they reached the top of a small forested bluff overlooking Nugget Creek, the female howled, calling to the others to announce their return. Silence reigned; no answer was made to her call. Upon return to the site, it became obvious why. Human footprints and the scent of man covered a chaotic and disturbing scene. There was no longer any reason to stand by.

As a pack they had often hunted goats or deer for sustenance, but with just the two of them, capturing larger animals would now involve both more luck and additional danger.

Challenging terrain, elusive prey, the risk of injury, and deep snow in the mountains above drove them down to the river valley, where they hoped to find their next meal. As they worked their way downslope through the forest, they encountered trails that were used by all sorts of creatures and provided easy traveling. As they were about to emerge from the cover of the quiet forest onto a rocky ledge, a busy and intimidating scene greeted them below: one with not only a lot of movement, but also a lot of noise.

Scurrying about on two legs were a bunch of creatures that the young wolf had never encountered and ones his mother had only occasionally seen from a distance. Caution would be needed in this new territory.

Before venturing any farther, the female took her pup off the trail and back into the trees to wait for the cover of darkness. While they waited, they explored the surrounding forest looking for clues that would tell them what other creatures lived there. Paramount was discovering whether any other wolves had laid claim to this land. Thankfully there was no scent or sign of any competition, and—better still—a strong scent of beaver rode the thermals up from the valley not far below.

When the sliver of a moon rose above the ridgeline, it provided very little light. This was no disadvantage to the two wolves because their eyes adjusted easily, enabling them to see better than any human, even a human with the aid of night-vision equipment. Within minutes they came upon a small stream running down from the ridge above. They followed it through an area ripe with the scent of beaver to where it crossed another trail, the likes of which they had never seen. Wide, black, and smooth—like the exposed bedrock worn down by the actions of the glaciers—it presented a very imposing, strange, and unnatural barrier.

The two backed away a few steps to watch from where the young forest provided good cover. When the coast was clear, they quickly crossed. A little of the warmth gathered from the sun earlier in the day made the blacktop surface feel warm and comforting under their wet feet.

As they listened to a wealth of unfamiliar sounds, their ears rotated back and forth, focusing on each one in the still night air. A maze of trails wound though a forest of mixed hardwoods and evergreens, and the abundance of new scents was nearly overwhelming.

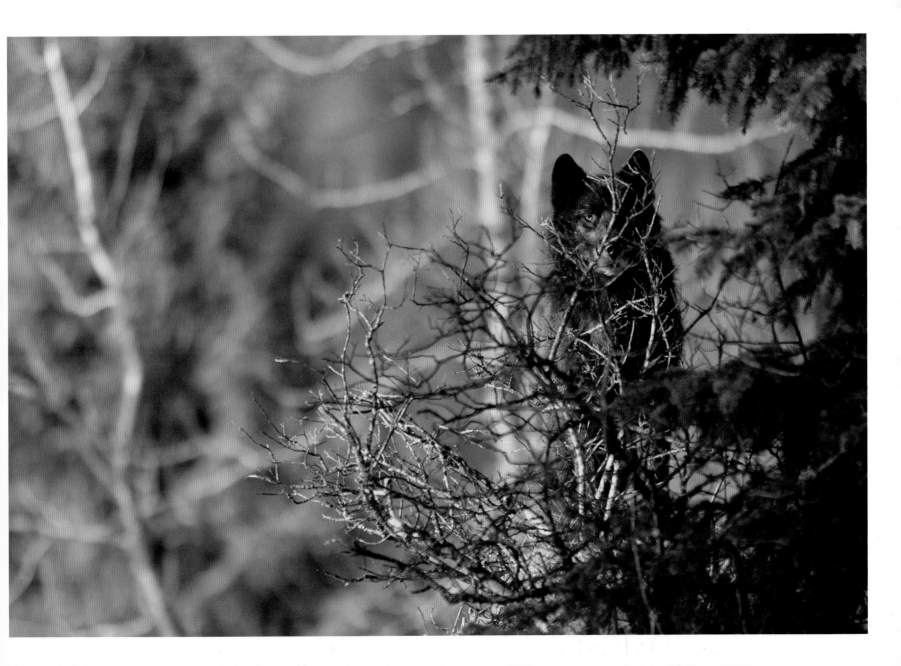

After finding a nice dry, sheltered place to rest, they bedded down and slept. The following morning a light misty drizzle fell, drops of water adorned the bare branches of the hardwoods, and the sharp green needles of the spruce trees that had provided shelter the night before glistened in the early light.

With the hunger of exploration burning as strong as the one in their bellies, the two wolves rose from their cozy beds and followed a small, brushy trail that ran close by. Soon they came upon a small meadow. Brown grasses beaten down by the weight of that winter's snowpack spread out before them. The female crept forward very slowly out from the cover of the forest and stopped abruptly in her tracks, as she picked up the faint rustling of a small creature moving in the grass immediately in front of them. Cocking her head back and forth, she stalked its movement and without warning leaped into the air and pounced,

head down, driving her nose into the dense mat of last year's sedges. She came back up with breakfast, which she gulped with one toss of her head.

The voles, now aware of danger, stopped all activity in their hidden tunnels beneath the grass. The alpha female watched and waited. Reading the severe glance of his mother, the young male froze. Focusing intently on the ground in front of her, she waited patiently, ears standing tall, curved over like satellite dishes, searching for the slightest movement below. Then it came, and she was airborne once again. Just as her feet left the ground, a gray blur streaked right out from where she had been standing. The young male darted forward but wasn't fast enough. His mother, more successful, offered the one she had caught to him.

The morning air was still as stone, providing the optimum conditions for tracking invisible voles moving about under the cover provided by the grassy tunnels below. The two wolves worked their

way through the meadow and with every second or third attempt were rewarded with another snack. The young male, no longer really a pup since surviving his first winter, was learning a new survival skill. These little creatures were all over the place, and if you could catch enough, you could earn a nap in the warmth of the sun as the morning's mist lifted from the land.

Weeks later on a dark night of heavy rain, as they moved between feeding and resting areas, the two wolves approached the road they had crossed weeks before, on their way from the forest above. The alpha female, now not quite as cautious as she was on the night they first arrived in the area known to local residents as Dredge Lakes, was getting used to all the noise that came with living on the edge of a world inhabited by humans.

Perhaps it was the blinding glare of suddenly approaching headlights that froze her in her tracks or possibly the hiss of the rain in the brush and on

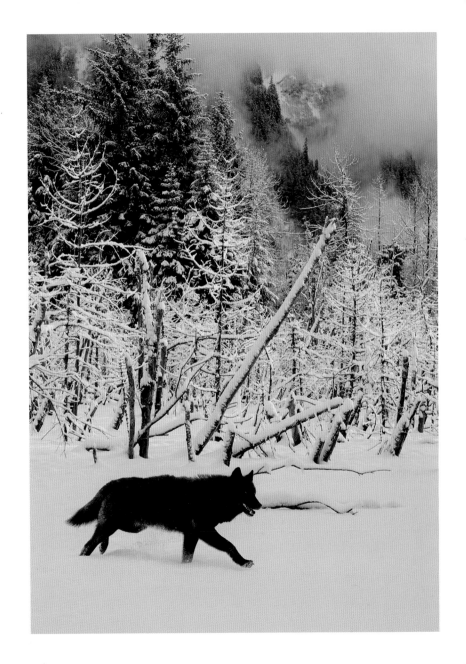

the pavement masked the sound of the approaching engine; regardless, the result was the same.

The driver of the vehicle called for assistance and the authorities who soon arrived on the scene tried to help, but her injuries were insurmountable. The young male—who, given all the commotion, had retreated into the forest—was now alone in a world he was just beginning to explore. The companionship and security of his family was gone, and he was on his own.

Thus came about the circumstance and the future fate of a lone wolf that came to be known, revered, respected, and even loved. A wolf that taught many people, even some who feared him at first, that wolves really weren't all that the fables and stories have made them out to be. That instead, wolves were just other members of the wild animal kingdom, ones that had as strong a desire to socialize and to be accepted, as they did to hunt.

A wolf that came to be known as Romeo.

One could ask how a wolf—an indiscriminate killer, one to be feared at all times—earned a name that implied courtship and love. The answer is simple: that was the only behavior he exhibited. All he ever wanted from others was acceptance and companionship, and he was willing to risk everything to obtain it.

## THE NATURE OF WOLVES

Wolves are the largest wild canines on our planet today. In North America there are two species of wolf, the gray wolf and the red wolf, along with various subspecies that are specific to the types of habitat they frequent. Other species of wild canines began to evolve from wolves about 500,000 years ago. "Man's best friend," the dog, diverged as a descendant of the wolf about 135,000 years ago. All are classified as carnivores. The wolf is classified

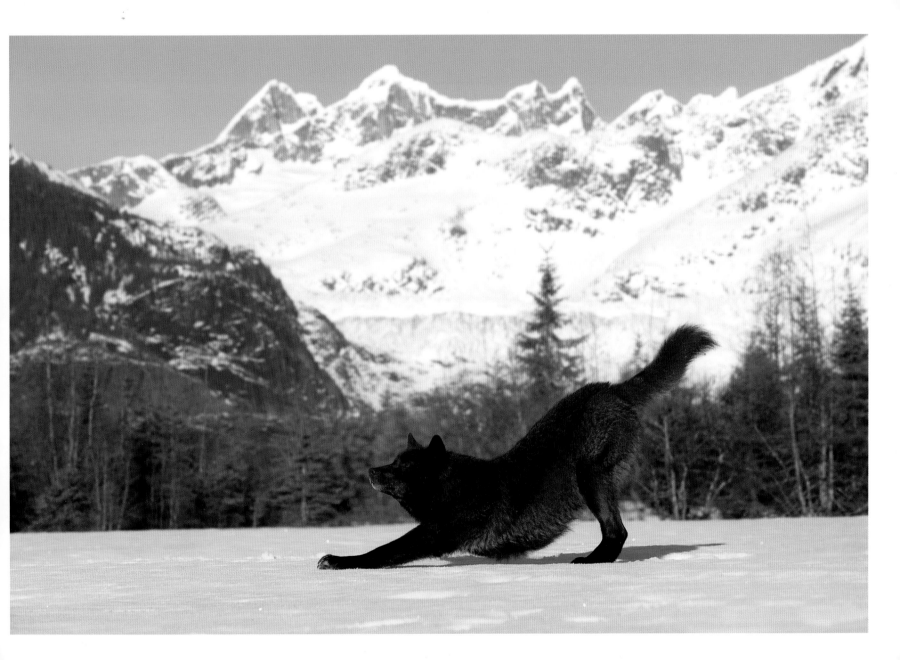

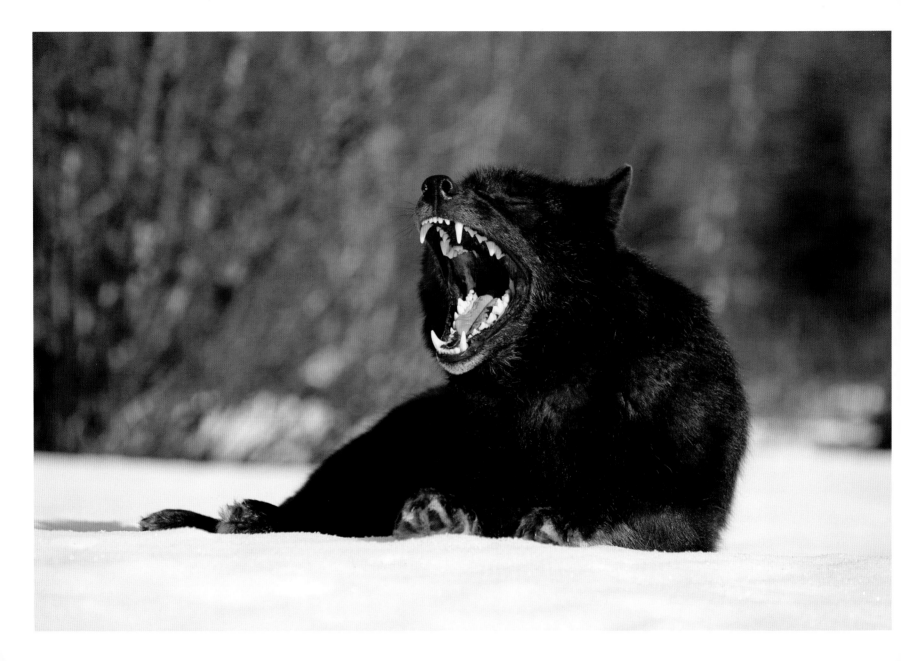

as follows—species: *Canis lupus*; family: Canidae; order: Carnivore.

There is no getting around it: As their order proclaims, wolves are carnivores; they eat meat. Typically wolves have forty-two teeth, rounded ears, a broad heavy muzzle, and a long lean body averaging 4.5-6.5 feet from nose to tail, and are 26-32 inches high at the shoulder. Their jaws are capable of generating 1,500 pounds per square inch (psi) of bite pressure. In comparison, a German shepherd's bite is about half that (705 psi), and ours is a mere fifth (300 psi).

The canine teeth of a wolf interlock, which enables them to hang on to large, struggling prey. They are sharp and pointed, and perfect for puncturing, gripping, and slashing. Their carnassial teeth are used to shear and tear once their prey is caught, and the rear molars are made for cracking and crushing bone to get at the nutritious marrow that lies within.

Typically wolves don't eat every day, but because they have high metabolisms, they need to eat fairly often. In one sitting they can consume up to 20—perhaps even 30—pounds of meat and they gulp rather than chew their food.

Unlike bears, who hibernate in the winter, wolves cannot slow their metabolic rates down to almost nothing. In winter, when environmental conditions become life threatening, it becomes even more important that wolves get as much food as they can to replace the extra calories they burn to stay warm.

Because wolves rely on their ability for explosive starts and long chases, they can't put on a lot of extra pounds. Lean but strong, explosively powerful but conditioned for endurance—that's the wolf.

Wolves in southeast Alaska, especially those in packs, require healthy populations of wild ungulates (deer, mountain goats, and moose) as the basis for their diet.

When Romeo was with the pack, when they all roamed free throughout the wilderness, they likely spent most of their summers in the alpine above or near timberline, hunting goat, deer, and perhaps marmots. At times they may have ventured along coastal corridors to the north or south and into river drainages that provided opportunities to hunt moose as well. And in the fall, when salmon are present in virtually every stream and river, finding fish to supplement their diets would be as easy as heading down to the closest supermarket. Most of the wolf populations in the northern areas of southeast Alaska are found along the river valleys and coastal mountains of the mainland. The largest islands in this area—Admiralty, Chichagof, and Baranof—do not have populations of wolves yet. But the islands just to the south and east do. In fact, it is those islands that are most well known for being inhabited by a subspecies of the gray wolf known as the archipelago wolf, a wolf that tends toward darker colorations than the traditional gray or multicolored pelts of its brothers and sisters to the east and far north. Romeo himself may have been an archipelago wolf.

More than twenty-five years ago and soon after my arrival in Alaska, it was his brethren to the north that provided my first close encounter with this oldest of the canids.

On a cloudy winter afternoon, while working with some research biologists studying wolves, we received word that the pack they were hoping to find had been spotted from a plane that was searching for them with radio telemetry equipment. One of the wolves had been radio collared previously, and they used the signal from that transmitter to locate the pack. We were gathered at a small landing field waiting for any news. When they called in the location, everyone jumped into waiting helicopters and flew directly to the scene. The pack had been spotted resting out in the open

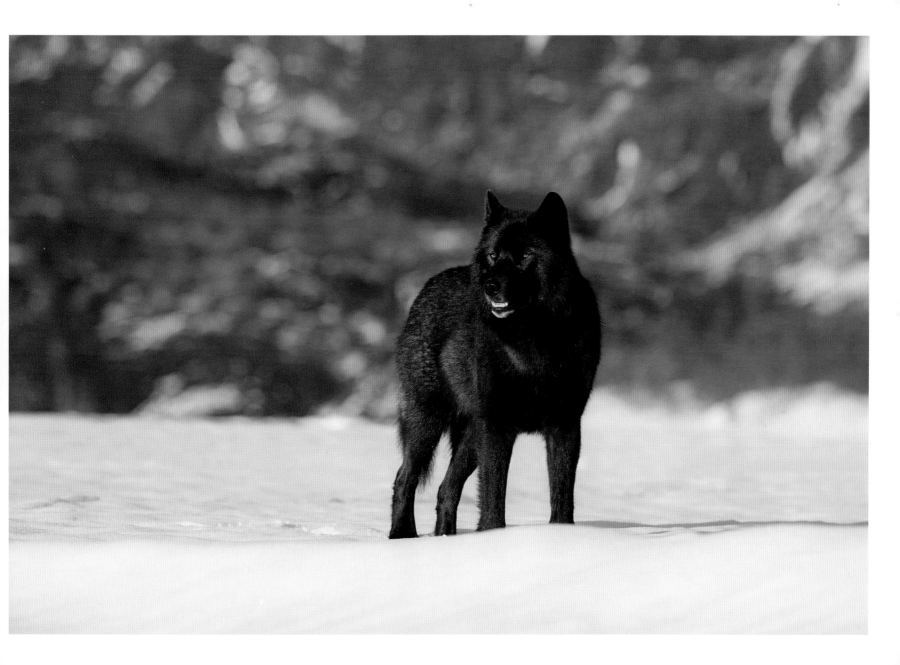

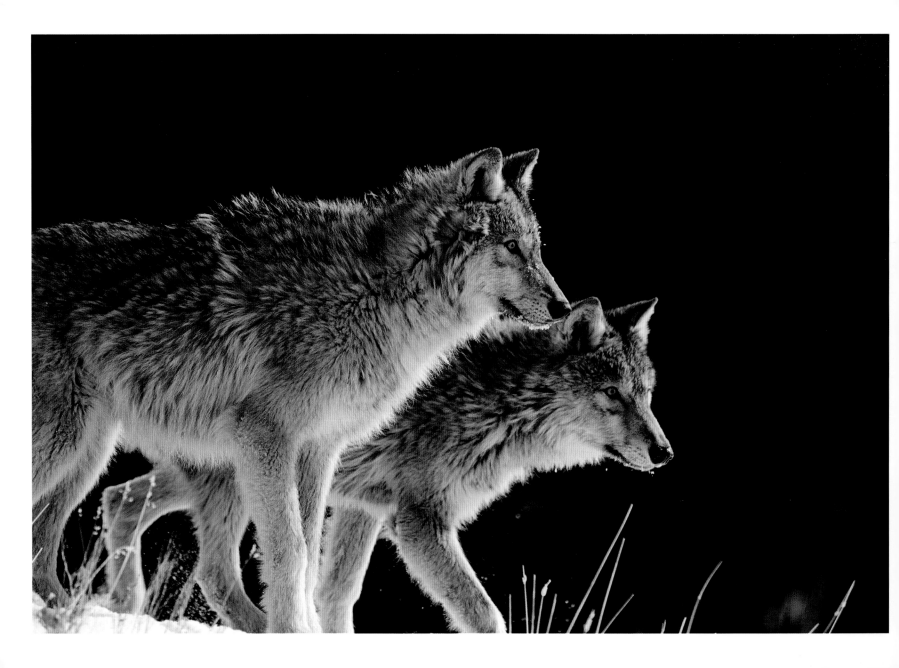

on the surface of a large frozen lake, and was split into two groups. The wolves had taken two caribou and appeared to have been feasting for a day or so. The biologists needed to temporarily capture a few of these animals to conduct various tests. The wolves barely looked up as we flew past, but when we circled back around, their concern increased substantially. The two helicopters split up, one going for each group of wolves, and the chase was on. Being hesitant to leave their hard-won food stash, the wolves didn't start to bolt until it was too late, and those who were the slowest made easy targets for the biologists with the dart guns. I don't remember how many wolves were darted that afternoon, but what I will never forget is trying to carry an adult male back to the helicopter.

The limp body wouldn't cooperate, and when I tried to get him up around my shoulders, I only managed to fall on my face in the snow. The pilot was yelling to hurry up, so I bear-hugged him under his front legs, lifted, and dragged him back to the helicopter. His belly was so full that it just rolled around like he'd eaten a bowling ball, which didn't make getting back through the deep snow any easier. When I finally got to the helicopter, the biologist who'd darted him helped me get the wolf into the backseat before we took off and headed over to the other site where the rest of the crew was.

This was one of the first wolves I had ever seen, let alone shared the cramped backseat of a helicopter with! He was so close I could smell his breath.

At first he couldn't really focus his eyes, but in just the few minutes it took to fly over and land by the others, he seemed to be recovering . . . quickly. His eyes had been rolling around, but now he was beginning to focus, steadily staring back at me a few seconds at a time.

That didn't help alleviate the feeling growing

quickly in my gut. What the heck was I doing with an unrestrained wolf in the back of a helicopter?

Flooded with relief, as the blades slowed and the swirling snow began to clear, I opened the door and passed the large canine as quickly as I could to one of the biologists, who immediately took him over to be weighed, aged, and tagged.

It was all over so fast, it seemed anticlimatic as we waited silently in the helicopters, listening to icy pellets of snow strike the plastic dome overhead. The biologists had finished conducting their tests but needed to wait for the wolves to recover from their anesthesia before leaving. One wolf got up and staggered off like a drunk down an alley, and within ten minutes or so, the others had joined it.

The three wolves that were darted that day were all multicolored. These are commonly known as gray wolves. Their pelts were a mixture of white, gray, tan, brown, and black. That is the most common coloration in central Alaska, the home of gray wolves. There was a female in that group that weighed in at 80 pounds (60-85 pounds is average) and two males, one 105 pounds and the other 125 (males average 80-120 pounds). The weight on these animals was high because they had just feasted on caribou, but it was late February, so their winter weight was likely less than their weight in late summer or fall; overall about average for a wolf, but nonetheless impressive.

Wolves in the wild live an average of six to eight years, and some have been documented to live as long as thirteen. The average life span is shorter for males than for females, perhaps because males are more likely to leave the pack, breaking away to form packs of their own. Injuries or death can also result during fights for dominance within the pack itself. And getting thrown out of a pack for insubordination can in itself become a death sentence.

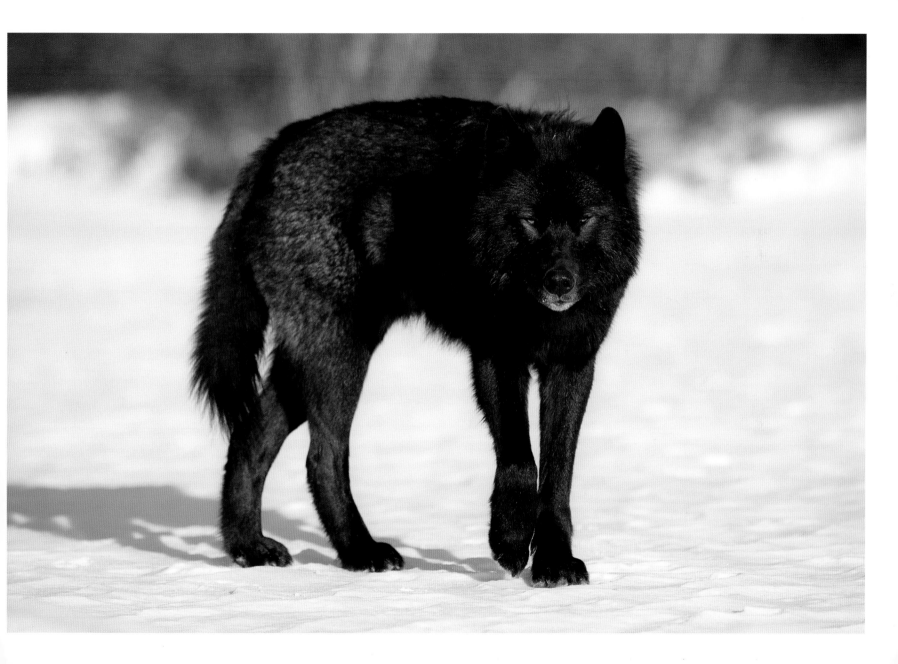

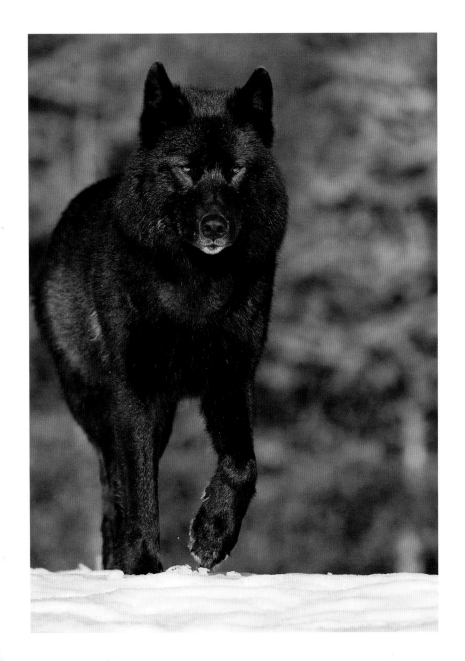

Being very family oriented with strict social structures, wolves tend to live in groups that provide a definite advantage for survival in the wild. A pack can take larger prey much more confidently and safely than an individual can. There is safety in numbers.

Wolf packs can be composed of as few as two animals or as many as thirty, but the average is six to ten. The larger a pack, the more food it requires to sustain itself, so the productivity of the environment and the abundance of prey species affects the number of animals in a pack. So do the number and size of packs in adjacent territories.

Another vital influence on pack size is the strength of the social dynamics within the family group itself. Strong leadership and committed followers make for secure pack dynamics. Otherwise, structure can begin to break down. When this happens, change will occur, and pack size will diminish. A pack may already be large

enough to create environmental or social stress. If a good summer season and gentle winter have ensured an increased survival of that year's pups, some members will move out on their own or in small groups unless competition from any neighboring wolves deters them.

Pack members are generally all related by blood except the alpha or breeding female. A family group may take in an "outsider" (in many cases, the animal that becomes the breeding female), but sometimes they will take in others as well. The alpha male might get killed in a battle with other wolves or succumb to injury or disease; in that case, the pack would be looking for a male outside their gene pool that would become the breeding or alpha male.

Only one male and one female are usually allowed to breed within a pack.

The mating season occurs in February and March, and this is a good time to listen for howling wolves. Lone wolves or wolf packs looking for a breeding female (or male as the case may be) will howl, in the hopes of finding potential mates.

The gestation period for wolves is sixty-three days, so the pups are born in late April or early May in an earthen den or a small cave or rock crevasse. Litters vary in size depending on the health of the female and available food supply. At about one month the pups are ready to emerge from the den but are not capable of travel until later in the summer. This is a time when pack dynamics become very important, especially to the survival of the pups.

The mother must be able to hunt so she can consume enough food to not only remain in good health but to provide milk for the pups. To accomplish this she needs babysitters she can rely on. Often these are adolescents from the previous year who will gain favor and standing by providing their services. Once the pups begin to wean, food

must be brought back to them and regurgitated so they can make the transition from milk to meat successfully.

Pup mortality can be as high as 50 percent, because of both environmental and social variables, and often occurs before the end of their first winter.

The leading cause of death in pups is starvation. Disease—such as Lyme disease, heartworm, parvovirus, and distemper—add to the challenges of survival. Parasites and insects can take a toll as well.

Adults can succumb to disease too, especially if weakened by malnutrition, but most often they die as a result of starvation or injuries from dominance battles with other wolves, both within and outside their own packs, and from injuries when hunting (getting kicked or struck or impaled with hooves or horns).

And, of course, there is the human element. Hunters, trappers, predator control agents, and folks who just don't like or understand wolves—or who aren't willing to tolerate the actions of predators—shoot, trap, or poison them.

## WOLF VOICES

Wolves have a wide array of vocalizations, visual displays, facial and body postures, and social rituals that effectively enable them to communicate a wide range of emotions, desires, and other information from both near and far.

Howling, the most well-known and recognized wolf vocalization, is used to communicate the desire to interact with others, to indicate location, even to identify individuals in a pack. Wolves in a pack can identify each member by the particular cadences of their howls, and locate each other or their possible rivals over vast distances when on the move.

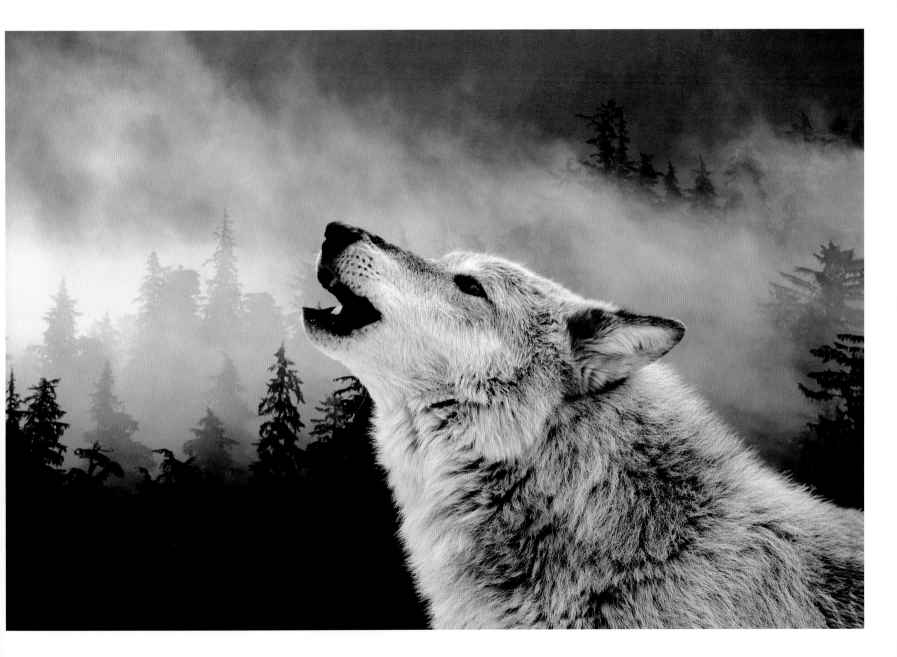

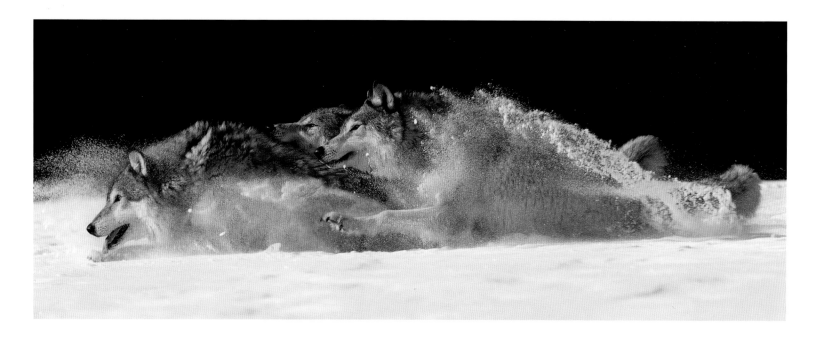

Howls can also be used in greeting, and two or more wolves can break out in a chorus of harmonized howls with stunning effect—so much so that "chorus howls" can be used to fool another pack into thinking that their numbers are more considerable than they really are. If the group structures its howls so one follows the other, by the time the third or forth howl is commencing, the first has died away and that animal is ready to howl again.

Once an alternating chorus gets going, it becomes very difficult to determine exactly how many individuals there are. The effect is enhanced because the individuality of each animal's call is masked by the howls of the others.

This helps packs maintain respect for each other and avoid confrontations that could arise from accidental chance encounters.

I witnessed this while observing a pack of wolves

in Canada's Yukon Territory. Eleven wolves had taken a large bull elk close to the Alaska Highway between Haines Junction and Whitehorse, and had been feeding for at least a day or two by the time we arrived on the scene. We didn't get much of an opportunity to do any photography that first afternoon, but that night we heard the distant howling of another pack of wolves!

The suspense of what might happen during the night nearly kept us from getting the sleep we needed, but the day's exertions won out, and soon all was quiet in our tent. The following morning we worked our way over toward the kill site but couldn't get as close as we wished without disturbing the pack. Later that afternoon, three wolves ran out from the kill, romping and chasing each other through the deep snow, right toward our blind, which resulted in one of my favorite photos of a pack in action.

After the chase was over, they moved back to

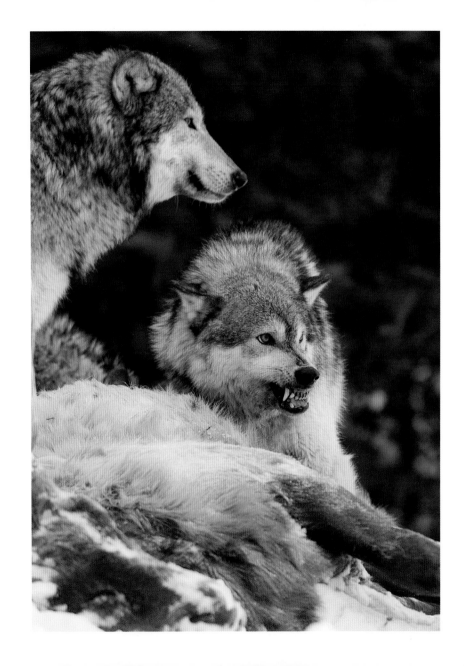

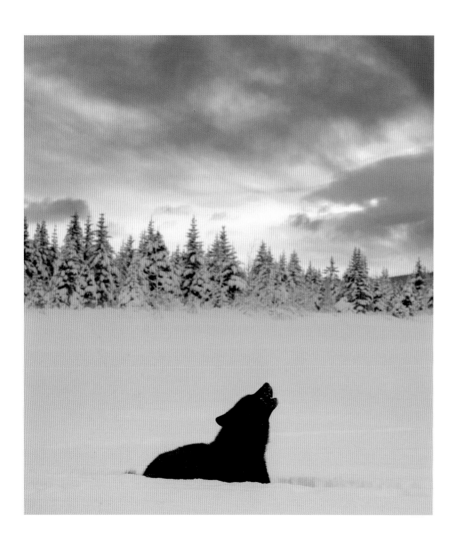

the carcass, and started to feed again. Just as the sun was about to set, the other pack began to howl again. This in turn set off a chorus howl among the wolves feeding on the elk. At first they stood tall, as if they were at attention, and a few climbed up on the elk while the others scurried around as if they were a team getting into their assigned positions.

First one and then another answered the call from their competitors, and it soon became an organized cacophony. Once the chorus howl was over, a questioning silence hung in the air as we hurriedly packed our gear, and headed back through the aspen forest and dusk to our camp about a half-mile distant. We heard brief howls, and again we rested in our sleeping bags with hot cups of tea warm in our hands, and bright stars overhead.

By the time we arrived at our blind the following morning, the pack had vanished. There didn't seem to be much left of the elk but hide and

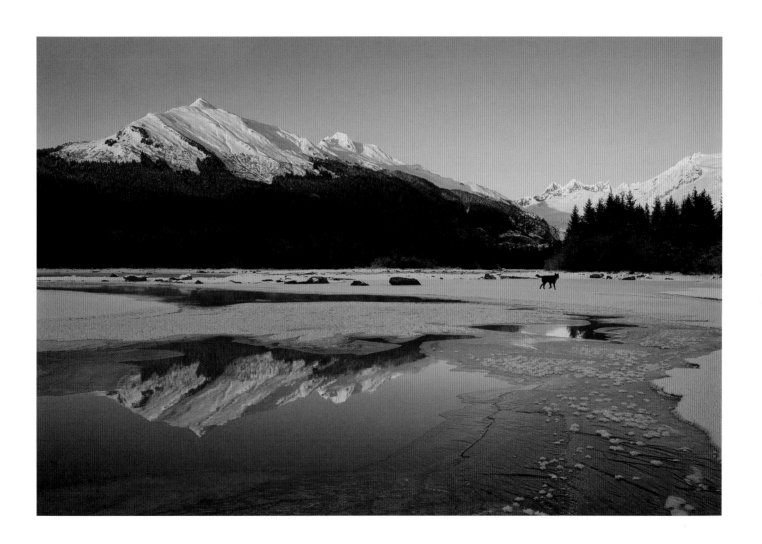

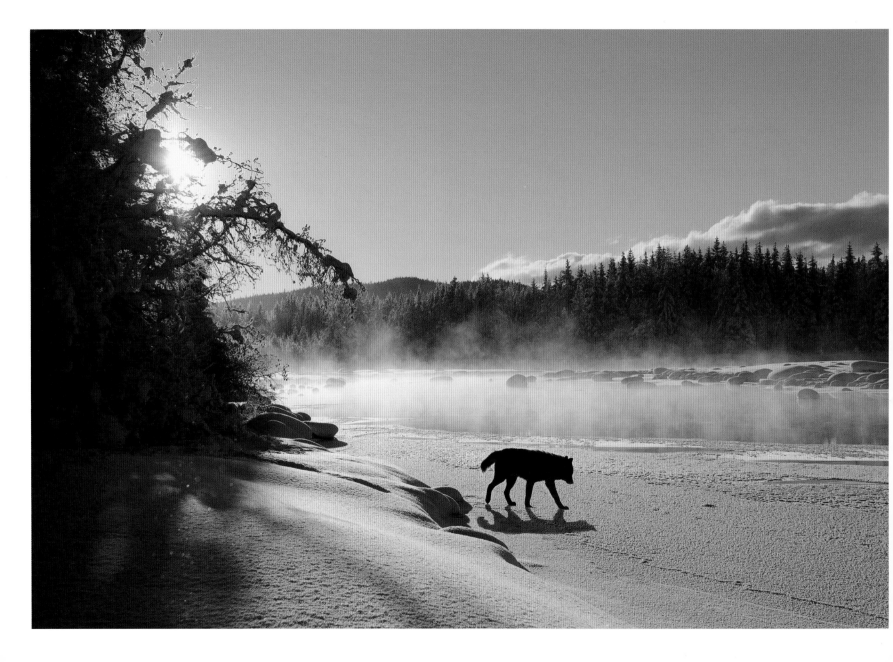

bones. Ravens sat about looking anxious, and one had taken up a position on the antlers of the elk. It took all the willpower we had not to go over and investigate the scene, but we didn't want to spoil it for the other pack, or for ourselves, should they suddenly appear. So we waited in our blind and observed. The tension in the forest was high, but we saw no wolves nor heard any howls. As we watched, ravens and crows picked away at the hides and bones and were soon joined by a few magpies.

Perhaps it was just our imagination, but we felt that the other pack was waiting for us to leave before they made their approach. We departed reluctantly, leaving what was left and the silence of the forest, to the wolves we hoped were waiting in the trees beyond.

When wolves do use howls to communicate, they usually do so judiciously. There is always the risk that a rival pack may try to sneak up on them, using the element of surprise to their advantage. The decision to howl or not is often left up to the discretion of an alpha animal—that way, the others reduce the risk of disciplinary measures.

The wolves on the elk didn't howl until they were tested by the other pack, which likely had been drawn by the scent of the elk. But they could also smell the wolves that were presently feeding on it and didn't want to be taken by surprise or outnumbered in a fight. So they communicated their desire to approach by howling and were rebuffed. The original pack staked its claim with their answering chorus.

But then, perhaps during the night, the pack we'd been watching decided they had gotten most of what they wanted anyway and what was left wasn't worth fighting over. So they departed, leaving it to the others. Perhaps they decided that the other pack may have been trying to goad them into attacking, by limiting the number of

their howls to make their numbers seem smaller than they actually were. There is even the chance that they recognized the rival pack and that some of its members may have been related, making the reasons behind any decisions even more complicated.

Considering that howls can be heard from long distances, wolves usually use them sparingly, especially when they are in or adjacent to the territories of other packs who may come running to discipline or even kill them.

During February and March, wolf howls often echoed throughout the Mendenhall Lake area, especially in the late afternoon or early evening. I always presumed this had something to do with Romeo's biological clock, that time of year being the mating season, but in the case of this black wolf, I was never sure. It was also the height of his social calendar. The lake and campground areas, because of reliably good snowfall and safe ice conditions, provided peak Nordic skiing and skating opportunities during the midwinter months, and people would bring their canine buddies out with them in force. Most people out at the lake with their dogs would head home by the time it got dark, so perhaps Romeo's howling was a kind of "last call" for the day, because he knew all opportunities for play were quickly going to fade as the light faded from the sky. Sometimes I'd be lucky enough to be in the right place at the right time, making it possible to get a few photographs of him howling, but more often than not, his lonesome call would drift my way on a gentle breeze or echo off the surrounding mountainsides. Success was not always guaranteed, during my quest to record the life of this wolf with my camera. On many outings, I'd return to the trailhead or parking lot having never made a single exposure and once in a while having never seen or heard any indications of his presence. But the suggestion of

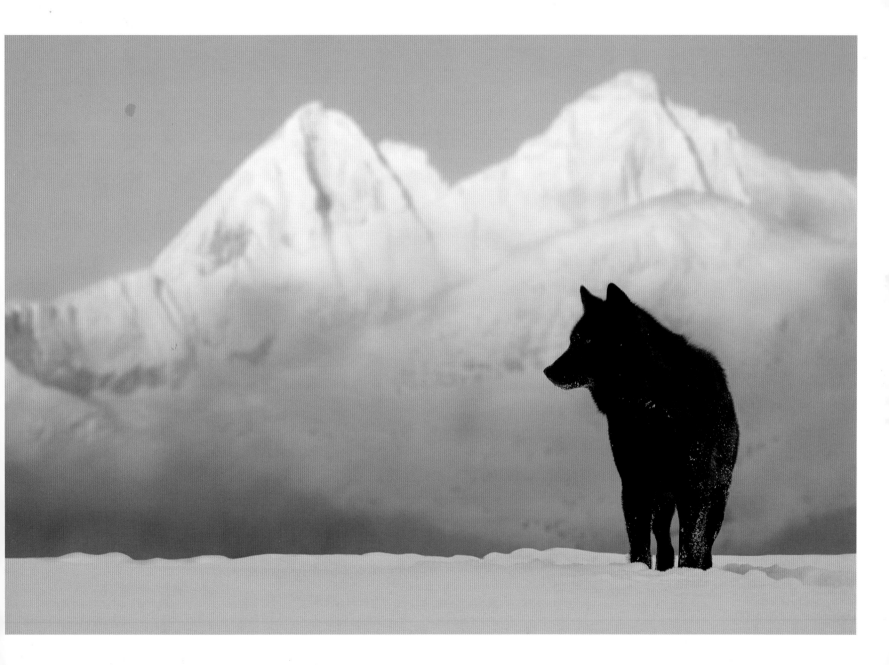

opportunity alone, from recent accounts by others or from his tracks in the snow, always provided incentive and reward enough.

## THE VOICE OF ROMEO

Wolves whine, whimper, yap, growl, bark, yelp, snarl, and moan when the occasion arises. Romeo made all these sounds. He was known for the whines and whimpers he often used upon greeting, which indicated his tolerance and acceptance of a potential playmate as well as his desire to play.

Some people misinterpreted these whimpers as indications of submissive behavior, which in his case they were not. In all the time I watched him, he never acted aggressively toward dogs, but when pushed, he either indicated his dominance through nonviolent physical posturing or by simply walking away.

Once, on an occasion when two German shepherds attacked him aggressively, I thought for sure he'd defend himself, but as soon as he could get loose of them, he walked away. The impression made by that encounter wasn't that he backed down but that he tolerated the aggressiveness of the dogs and for some reason didn't kill them for it.

Even though they had torn substantial amounts of fur from his back and shoulders, Romeo didn't seem any worse for wear. And the shepherds didn't pursue him once he broke away from them, even though they were the ones who approached at a run and initially attacked. So it was obvious they knew not to push their luck any further. Stopping and looking back as he walked away, Romeo tilted his head at an angle and with an inquisitive look on his face, proclaiming, "Why? Why don't you want to play with me?"

Barks are usually used by wolves as an alarm or to challenge, but after years of socializing with

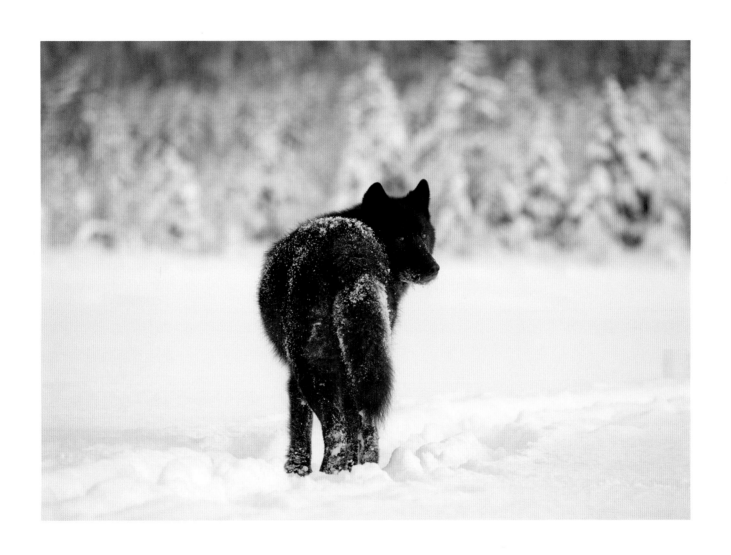

dogs, Romeo had learned to use barks to announce his presence, at a distance, to those with whom he wished to socialize. He'd learned to speak Dog as well as his native Wolf.

Growls are used to challenge or to proclaim dominance. They are also used to discipline pups, and are often accompanied by bristling and raising the hair on the face, neck, and shoulders.

Wolves also use postures or body language to communicate. For the wolf—whose primary objective is survival, and for whom, therefore, the use of physical aggression is a last resort—effective communication skills can be lifesaving.

Facial displays are used to communicate anger, fear, aggression, dominance, and submission at close distances. Romeo's facial displays ranged from comical to stern, with just about everything in between.

During confrontations or upon meeting others, wolves will stand tall, raising their ears, hackles, and tails, all in the effort to appear as large as possible. Size is often related to dominance, so the *illusion* of size counts for something too, especially at a distance.

There are two levels of submission: active and passive. During active submission, wolves will crouch, lick their muzzles or the muzzles of others, and tuck their tails between their legs. During passive submission, they may lay on their backs, exposing their underside to the more dominant animal. When expressing fear, wolves often tuck their tails between their legs, lay their ears back, or bare their teeth from a crouched posture. Submission can also be expressed by lowering the tail with the tip curved back.

Suspicion is demonstrated by laying back the ears and squinting, often in a defensive posture, with the tail held out straight and the teeth bared. Once defensive actions escalate, they raise their ears and continue to bare their teeth. When anger

evolves into attack, the ears turn forward, the tail lowers, and teeth are bared.

But during play, just about all these postures might be used by the dominant animal to entice the other to respond and to give chase or play. The most physically aggressive act I ever witnessed in Romeo was one in which he would use one of his forelegs to sweep the aggressor off its feet and onto its back. This happened so quickly that the dog would be standing one second and looking up from the ground the next. The dog always took the hint and abandoned its previously aggressive behavior. Usually within seconds they would be back at play, dog and wolf having a great time and enjoying each other's company. Not once did I ever see him bite another dog. Biting was clearly the last resort, and the line that was not to be crossed.

When Romeo spotted a potential playmate, he would usually approach directly from a distance,

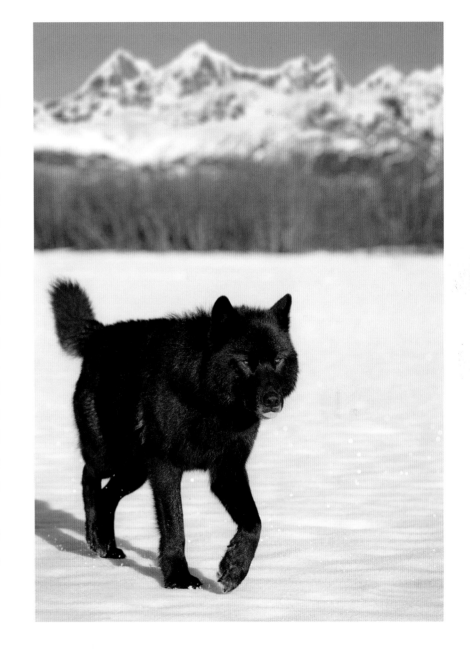

and then stop 50 yards or so away. Out in the open on the lake, there was no mistaking him. A big black wolf approaching fast is hard to mistake. At other times, when he was along one of the trails in the forest or over in the Dredge Lakes area, you might hear his whine before you saw him. If you were with a dog, you might have turned, wondering if something was wrong. Perhaps there had been an encounter with a porcupine or some other hazard? But then turning around, you'd be confronted by a big black wolf standing there looking anxious and hopeful. I heard quite a few stories from dog owners experiencing exactly that, but they need not have worried. The anxiety and hope were for a playmate, not a meal.

If a potential playmate looked receptive, Romeo would take a few bounds forward, stop, spread his front legs out straight in front of him, lower his head between his paws, and look up inquisitively. If the dog just stood there or approached tentatively, he would stand back up, walk slowly forward, and possibly touch noses with the dog. But if the dog reacted positively to his bow, he'd often jump up, whirl around, and run off, hoping the dog would give chase.

These games of tag might last just a few minutes, or range, off and on, for more than an hour. Usually the dog or its owner grew tired and wanted to move on, but sometimes they'd all just continue, Romeo joining them on their walk. Usually he would keep his distance and often move to the lead, exhibiting typical alpha behavior.

If the person called their dog over and leashed it up, walking away, Romeo would often just go and lie down in the snow along the lakeshore and watch for his next social opportunity. Sometimes if people and their dogs sat down to take a break, eat a snack, or have some refreshment, he'd plop down not far away and rest too, as if hanging out with his buddies. It was obvious that all he ever

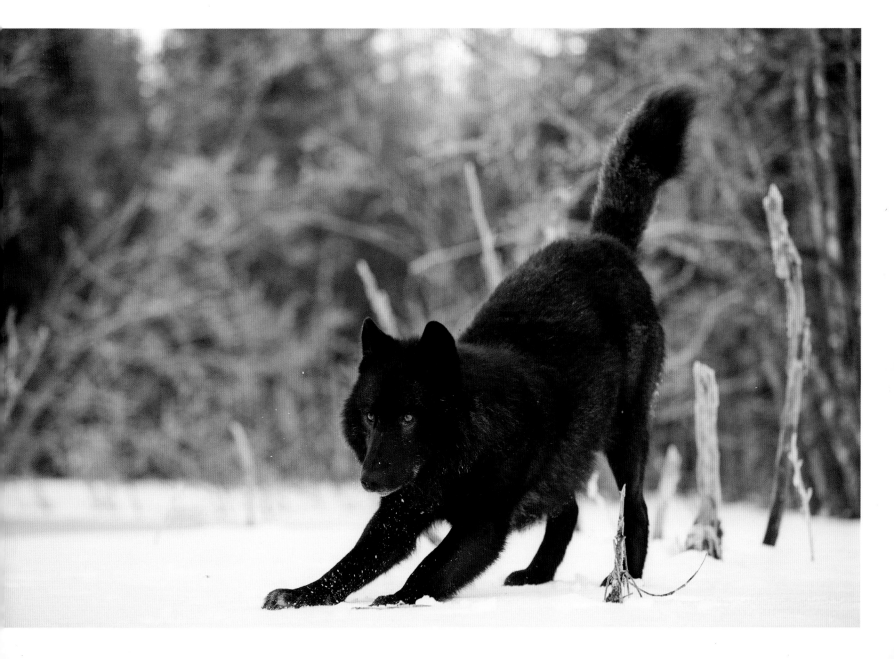

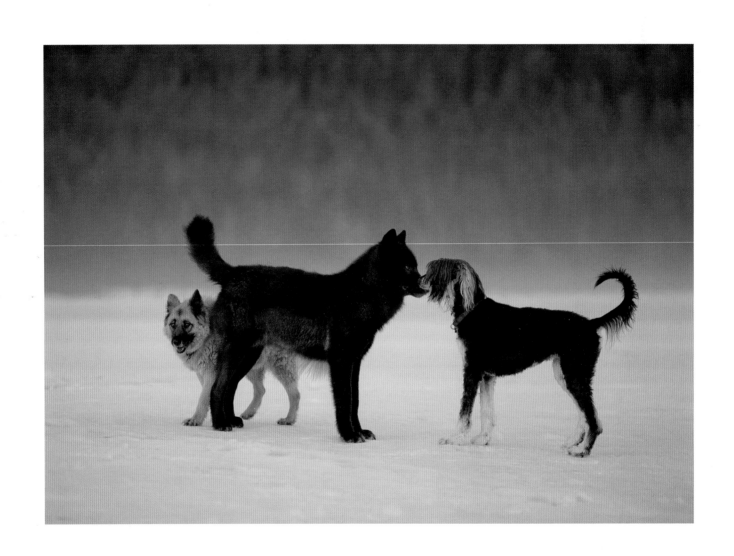

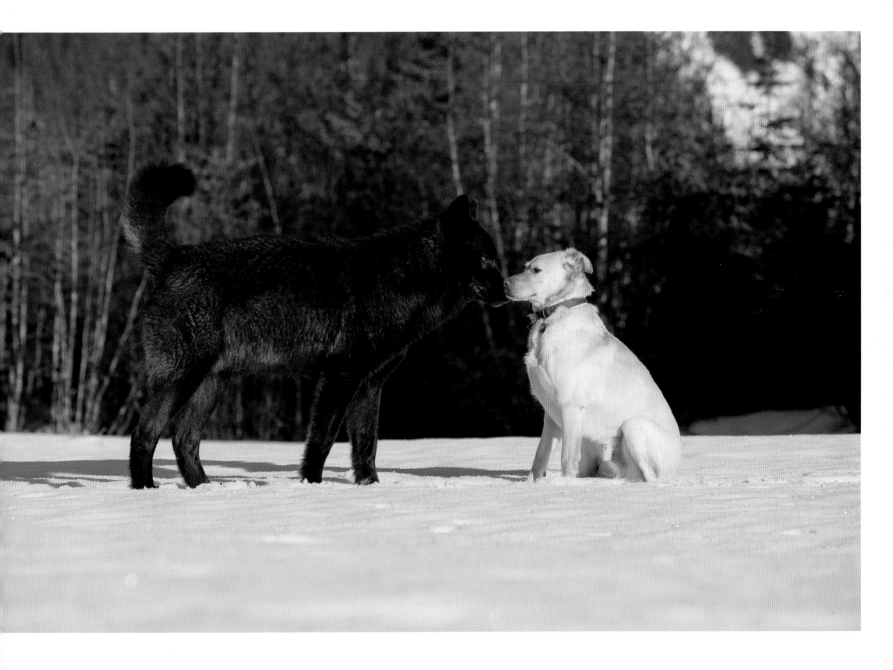

wanted from these experiences was to be part of the gang, or, in his eyes, to be accepted by the pack and have some fun.

## DOGS ARE NOT WOLVES

Wolves depend on communication through body language more than domesticated dogs do. Wolves in the wild have very similar physical characteristics, which enable them to develop similar signals that are easily understood by all. Domesticated dogs, on the other hand, can have very different physical characteristics that have evolved through breeding. In part, that's why there are so many different-looking dogs. Some have long tails with lots of fur, and some don't have any tails at all. Some have so much fur or hair that you can hardly even see the dog underneath. Others have ears that hang down instead of pointing up. They can have short noses or long noses. Their sizes can vary from tiny to huge. All of these things can confuse a wolf.

A lot of wolf body language depends on the position and structure of how the ears and tails are held, but when these physical characteristics are so varied or simply missing, so are the clues they represent. Some of the major and many of the finer nuances of communication by body language are lost within these differences, sometimes limiting communication to howling and barking or smelling. Because wolves do not normally socialize with dogs, this usually doesn't present any problems.

On a number of occasions, I watched Romeo go through his routine with a dog that didn't quite understand what Romeo was trying to communicate. The dog responded aggressively because it either thought the wolf was being submissive, giving the dog the idea that it could get the upper hand, or misread Romeo as aggressive.

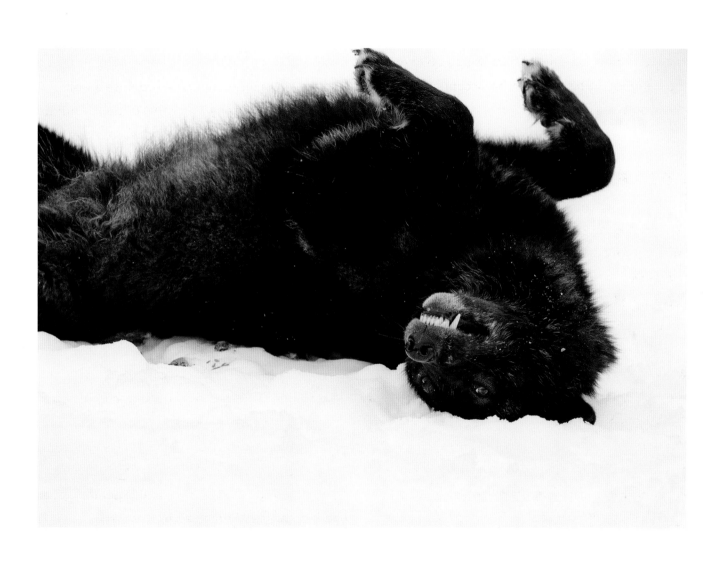

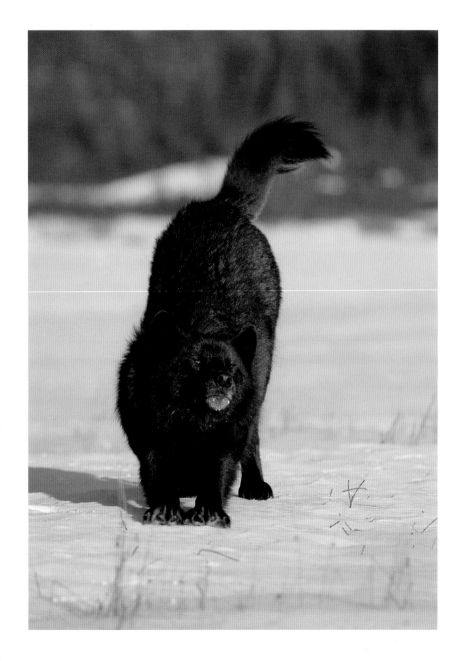

Either way, it wasn't long before the dog forgot it was the original aggressor and would start to play with the wolf. Sometimes this transition was so seamless it was difficult to tell exactly when the switch was thrown; which, of course, had been the exact intention of the wily black wolf from the start. Whenever an aggressive dog confronted him, Romeo would entice the dog to give chase, which it usually did, quickly and enthusiastically. Romeo would streak away from his potential playmate as it pursued what it believed was a submissive wolf. Just as the dog was about to convince itself of its superiority, Romeo would quickly pull away or change direction, leaving his pursuer in the dust.

As the dog stopped for a second, looking dazed and confused, Romeo would rush in aggressively, slow down just as he was about to reach the dog, stop, and posture submissively, getting the dog to chase him again. Back and forth it would go until

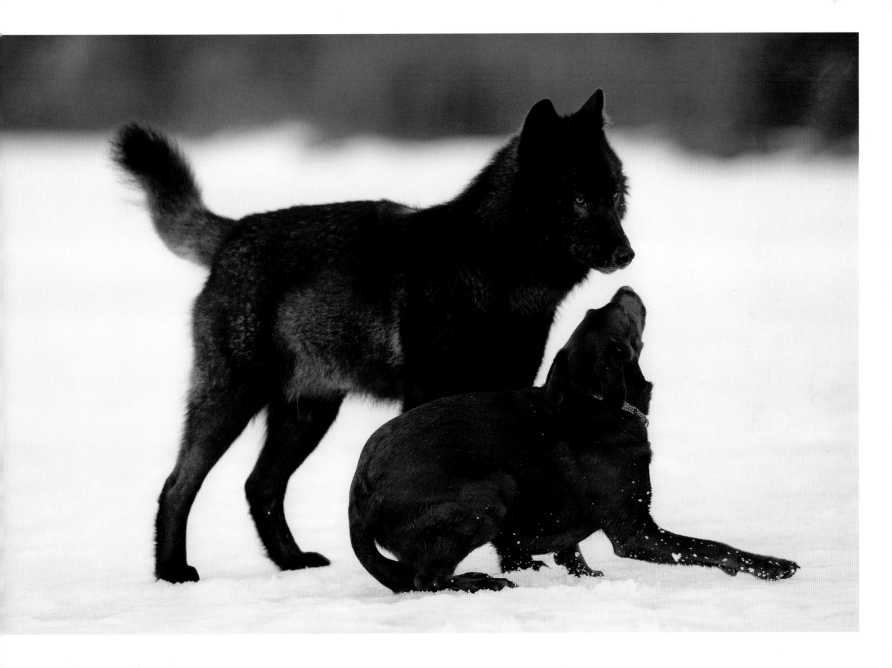

  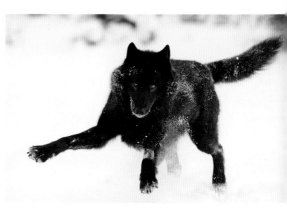

the dog had exhausted any aggression and was freely playing a game of tag with the wolf.

On more than one occasion, I got the strong feeling that the wolf wasn't aggressive with the dogs because he understood the aggression they exhibited wasn't part of their true nature, but just pent-up energy they had to get rid of through exercise before they could relax enough to play. Free in the great outdoors all the time, the wolf was never confined and didn't have the resulting frustration as part of his psychological makeup.

With a nose about 100 times more efficient than ours, wolves communicate with their sense of smell as well. Perhaps the most obvious example is scent marking, which can be accomplished by urinating or leaving scat in areas that are central to movement, such as junctions in trails or on objects that will help disperse scent in the air (like stumps, tree trunks, branches, logs, rocks–anything that projects into the air where even a slight breeze can disperse the scent). They will also scent mark an object that will absorb and hold the scent, making it last. That's why dead standing wood is a favorite scent post. Wolves rub against these objects to mark them with their scent glands.

Scent marking is used to mark territories and to tell other wolves who has been where and when. It acts like that yellow blinking caution light in the

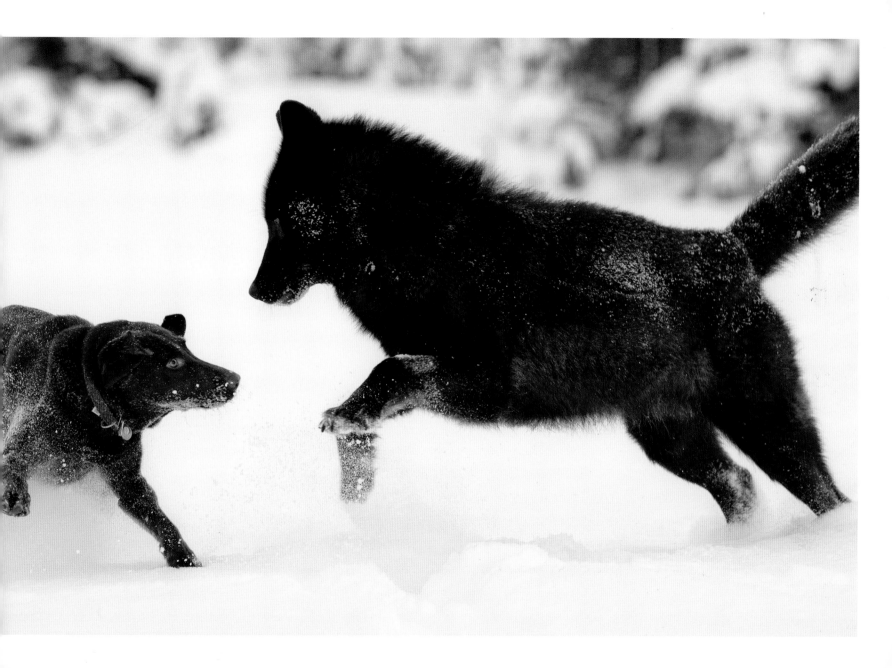

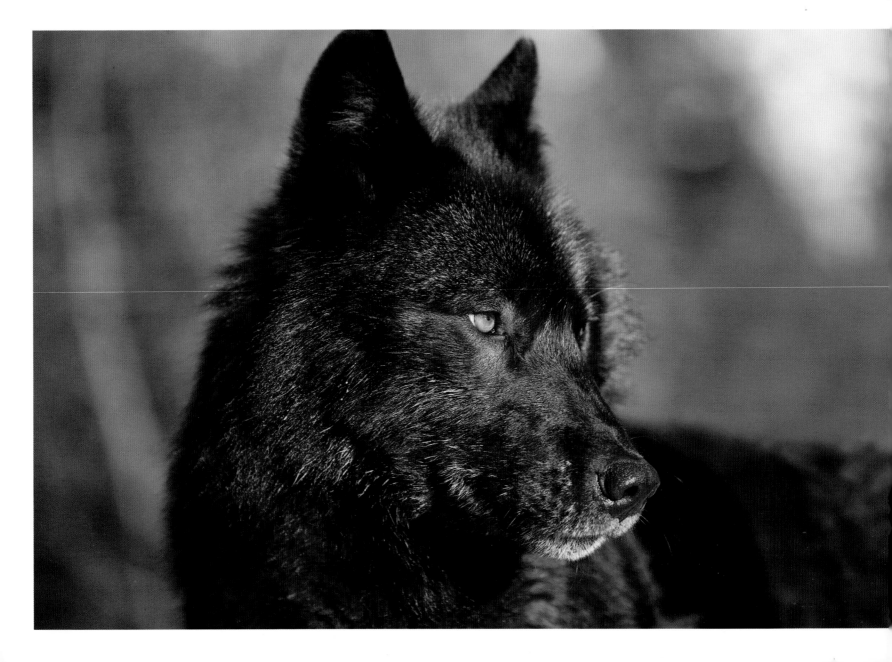

intersection down the street, by providing a warning to other wolves that have ventured out of their own territories to beware. It can let separated individuals in the same pack know that the other was here yesterday. Scent marking is the message board of the wolf kingdom. Romeo would repeatedly mark various locations along the shoreline of Mendenhall Lake and near main trails, especially intersections in the surrounding forests.

Of course this incredible sense of smell, providing 200 million olfactory cells' worth of information, is also used by wolves to find and locate their prey.

In Alaska's interior and northern Canada, wolves in packs concentrate on prey species such as caribou, moose, musk ox, and beaver. In coastal areas, the caribou and musk ox are replaced with deer and possibly elk. Dall sheep and mountain goats might also be important in certain areas. Farther to the south, bighorn or stone sheep may replace the Dall sheep, depending on the location. Bison are also prey around Yellowstone and Wood Buffalo National Parks.

Wolves in packs hunt larger prey animals because they can do so with more efficiency and safety than lone wolves, and because their high metabolism demands they have an average of 2½–4.0 pounds of meat per day to survive.

Surprise is an important hunting technique for all wolves, but particularly for lone wolves. Wolves in packs can run down their prey by trading places as the primary pursuer, providing relief for each other during a chase. Lone wolves use ambush as their primary hunting technique, and usually concentrate on hunting smaller species, such as beaver, rabbits, voles, upland and water birds, and the occasional fish, deer, or goat.

Romeo's scat sometimes contained large amounts of deer hair and occasionally mountain goat, but I never saw him take down an animal that large, or found him on the carcass of one. That

doesn't mean he couldn't have accomplished such a feat. He could have. But he could also have been scavenging the carcasses and hides that hunters dumped along roadsides. Wolves are scavengers as well as predators, calories being the primary objective.

You could tell a lot from his scat. Deer hair meant that the region had experienced record winter snowfalls that had resulted in the cold killing or weakening many deer, making them easy prey for a hungry wolf. If, in the following year, his scat had very little deer hair and often contained beaver and what appeared to be vole hair, that meant that there hadn't been nearly as much snow, and deer populations were down from the effects of the previous winter.

The element of surprise was a technique Romeo used to his advantage often enough to be witnessed on a number of occasions by different people. The first time I saw him actually succeed in a predation attempt was in the fall along the shoreline of Mendenhall Lake. A flotilla of icebergs was suspended in golden reflections created by the willows and cottonwoods growing along the western shoreline.

The sun was out, and it felt so good I couldn't justify taking the trail that ran just inside the edge of the forest; instead, I hiked the shoreline, basking in its warmth. About a half mile from the trailhead, a small stream cut through the sandy bank and fanned out onto a small braided delta before reaching the calm waters of the lake. As I picked my way through and across these braided waterways, I was thoroughly absorbed in enjoying the morning sun.

The tracks of a wolf took me by surprise. The edges of the track were sharp, with very little debris in the depressions where the pads and toes had pressed into the soft earth. And the compressed sand at their bottom was darker and damper than

the undisturbed surface of the ground around them. Fresh tracks—*really* fresh tracks! And they were the first I'd come across since early August.

I was now fully alert, and pretty sure I knew the canid who had left this sign. Sitting down on a warm, dry rock worn smooth by the passage of the glacier a mile or so in the distance, I gazed at the shoreline for movement or some dark shape that might be a wolf lying in the warm sand. Nothing registered, so I got my binoculars out and scanned the scene again, this time slowly and more deliberately. All was still, except for a lone eagle perched at the top of a small cottonwood, hoping to spot a salmon in shallow water.

The sun was still warm and I was in no rush, but eventually I headed down toward a small beach where I knew a spur descended from the main trail running along the ridge above. There are only two options once you reach this point: Take the spur, or climb up and over the steep, brushy rock face

around to a point where a ledge of bedrock juts into the lake. From there you can again take to the shoreline and proceed as far as the glacier, about another half mile away as the crow flies. So I took a long pull from my water bottle, and started to climb.

The going was a bit more difficult than I had remembered, but after a few slips, a few pokes in the eye, and crawling under rather than through or over some particularly thick brush, the point finally came into view. Just as I worked my way around a small spruce tree, I saw a movement in the water close to the shoreline. A beaver using its big flat tail as a rudder was working its way back from the opposite side of the cove, pushing a large branch of willow as it advanced. A few minutes later it began to drag the branch up onto the shore.

The beaver was about 150 yards down the shoreline from me. As I reached for my binoculars to get a better view, a large dark object streaked

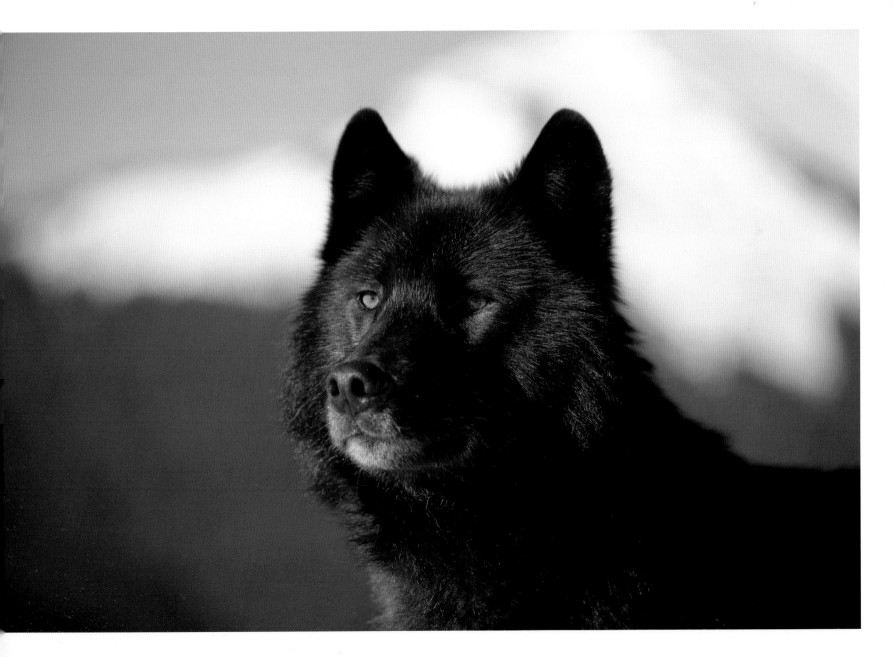

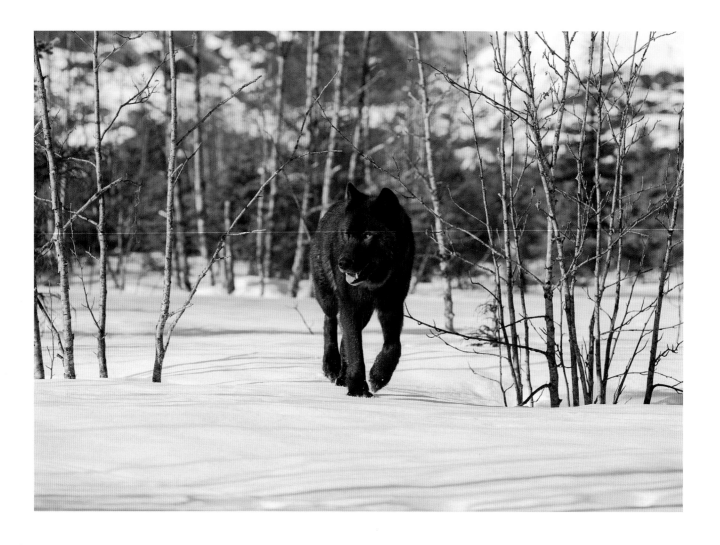

out of trees and leaped right on top of the beaver. I debated whether to try to get my camera out and take a photo, or just watch. Regrettably, I hadn't come prepared with the right lens, and because the moment was precious, I left my pack zipped, and watched instead. It was the right decision. Before I knew it, the black wolf had pulled the limp body of the beaver out of the shallow water, and in about three or four strides had disappeared into the vegetation.

Stunned, I sat there for at least thirty minutes watching the brush for movement and listening for any crows, magpies, or ravens calling from the trees—for anything that might tell me how far or where he might have gone. Nothing gave me any clue to where Romeo had gone. All was quiet.

Eventually I rose from my perch with the knowledge that Romeo had "returned to the 'hood'." I continued on to where the face of the glacier was pulling away from the bedrock beneath it, finding an ice cave to photograph over the next few hours. I thought of the stories about Romeo in the news that had been speculating whether he'd return that fall. It looked like we were indeed due for another season of the wolf!

Pet dogs are fed, but wolves must hunt. Predation is not gratuitous violence; it is the act of obtaining food. Opportunistic in nature, and focusing on obtaining the easiest, safest, and most available food or prey species, carnivores must hunt to survive.

If the beaver or rabbit or moose population is particularly abundant, then that is where they will concentrate their efforts. Like a good business-man, the wolf will choose whatever provides the most reward for the minimum investment. If a busi-nessman measures life in dollars, wolves do so in calories.

The wolf is designed for running, catching, kill-ing, and consuming virtually any animal with which

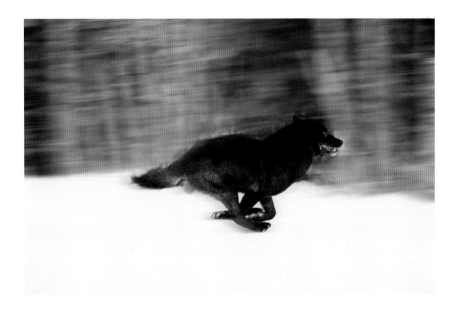

it shares its habitat. If prey is scarce in one area, a wolf can easily put 20—even 50—miles behind it in a single day, loping (or trotting) along at between 5 and 10 mph for hours on end. When it needs to, a wolf can rush forward in bursts of speed up to 35-40 mph, can clear between 20 and 30 feet in a single leap, and jump vertically more than 6 feet. Wolves have amazing stamina, endurance, and explosive power that allows them to range and hunt over vast territory. In northern Alaska and Canada, wolves still have territories up to a thousand square miles, and their ability to cover a lot of ground is vital, as the caribou move over the tundra like waves upon the ocean. With the ability to spend as much as 35 percent of their time on the move, eight to ten hours a day, wolves can keep up or catch up with any prey.

Back when grasslands reached from the Mississippi to the Rockies and from Oklahoma to Minnesota, and buffalo roamed in herds so large they reached from one horizon to the next. The ability to be in one place one moment and another soon after, kept the prairie wolf alive and well fed. With their long legs, and a narrow body profile centered over large front feet, wolves are efficient movers who can travel tirelessly, hour after hour, over all types of terrain.

Unlike the domestic life of the dog, living in the wild means the wolf never knows for sure where its next meal will come from, so conserving calories

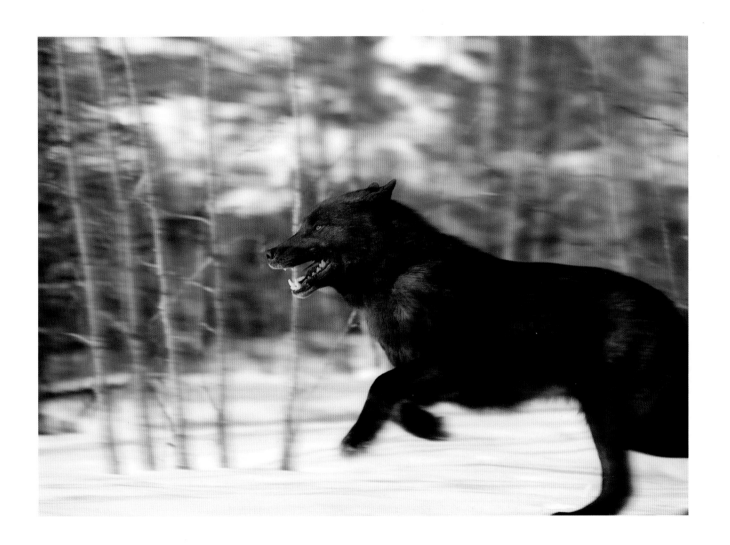

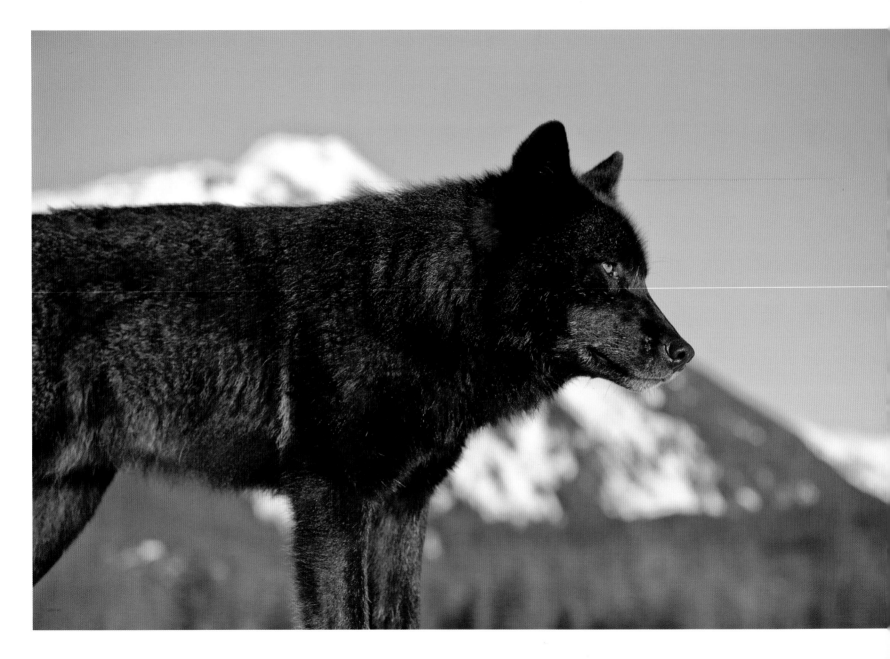

is paramount to survival. If a wolf doesn't need to move to eat, it won't. If the snow is deep, it will take the route with the least resistance, often following in the tracks of others, or along windswept corridors and shorelines.

Aside from the opportunistic use of the chance meeting with prey, tracking and scenting are used to locate subjects. When following a scent, or traveling in the hope of running across the scent of potential prey, wolves usually travel into or across the wind. If there is no wind, they will hunt against the daily thermals: downhill after the sun has warmed the earth, and uphill and cross slope at night. Just because they scent prey doesn't mean they will make a kill. I watched three wolves make attempts on a herd of goats for almost twelve hours before they finally gave up. It seemed the goats were almost playing the wolves. They would venture out into the open to graze on more gentle slopes, seeming to entice the three wolves.

Whenever the wolves attempted to move in on them, the goats would slide back into the rocks and cliffs, vanishing into their hidden rocky refuge.

## FISHING WOLVES

The first time I saw wolf tracks in the Mendenhall area, I had just crossed a beaver dam to get to the other side of a small slough, which ran out as a shallow stream to the lake below the dam. A small population of silver salmon spawned there each fall. The wolf must have been looking for a fish dinner.

In many of the coastal regions of Alaska and British Columbia, salmon are the one source of protein all carnivores (and omnivores) can depend on, at least seasonally. Even wolves have learned to eat fish! Some merely supplement their diet with a bit of fish here and there, but others learn to

fish as well and as dependably as their furry neighbors, the bears. Fishing wolves tend to concentrate on areas where salmon are forced into shallow waters—along shorelines and on gravel bars—and it was in just such a place that I watched my first fishing wolf.

I had come across a location where sockeye salmon returning to spawn had to cross a series of very shallow gravel bars that extended all the way across the stream. The bears here were not habituated to people, so it was necessary to use blinds and to work against the wind to get any photos. The fish were just starting to arrive; the bears had not really settled in yet, and the action was pretty slow. The sockeye coming upstream would swim up against one of these gravel bars and then settle back into the downstream pools to rest before moving on. The fish were not anxious to place themselves in a situation where, half out of the water, they'd have to wiggle and thrash like crazy, hoping to make it

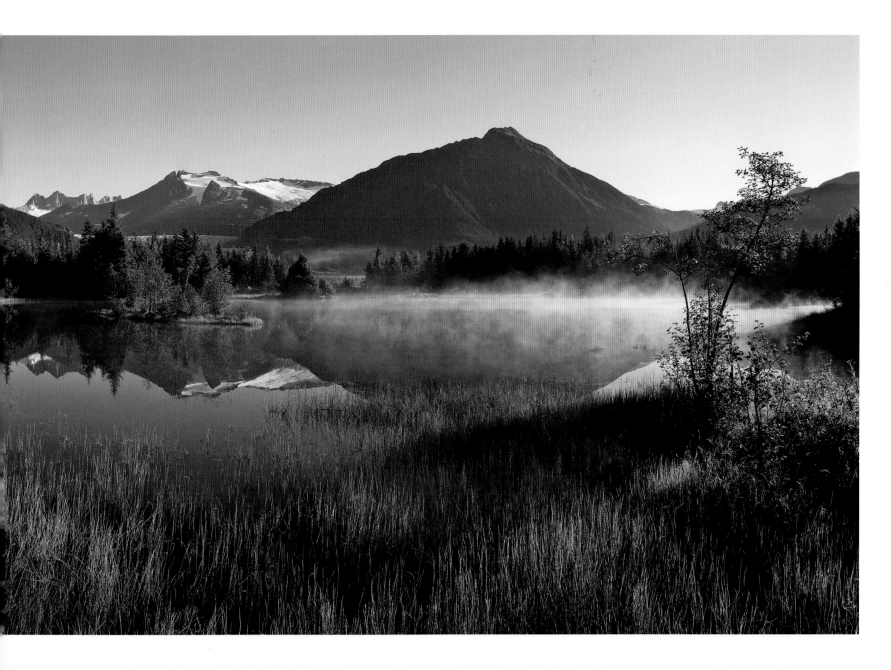

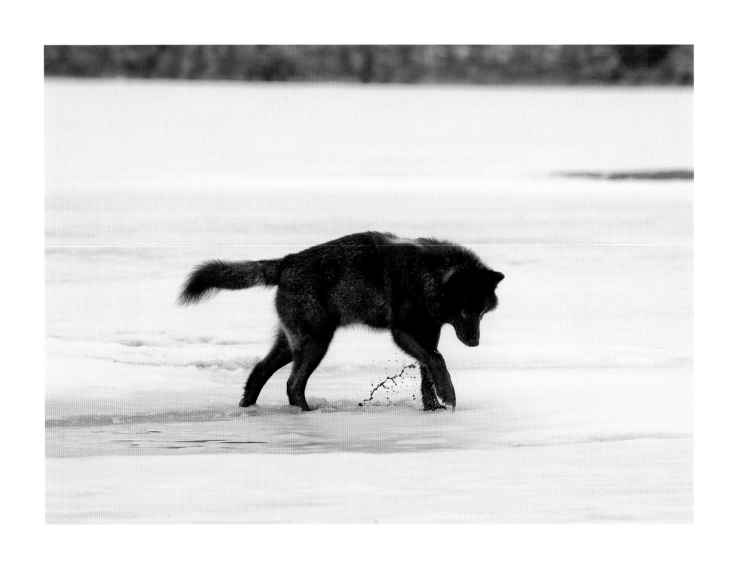

across the bar into the deeper water beyond. So they waited, and watched. Sooner or later, a few of them would get impatient enough and swim right up to the downstream edge of the bar, stick their heads out of the water, and check it out. Sometimes they'd go for it, but usually they just settled back into the deep safety of the pool to brood about it a while longer.

Gradually the pool would begin to fill up, and tensions would rise. Eventually one, then another, would make a go for it; then the temptation would be too much to resist, and they would all make a mad rush over the bar. Hundreds of salmon putting every bit of strength and power they had into a chaotic rush to get through the shallow inch-deep water made for quite a ruckus.

This was the signal that usually drew the bears out of the tall grass, and with a burst of speed, they came running to the shoreline. The lack of action on that wet misty afternoon and the confinement of the blind had nearly put me to sleep. All the false starts and false hopes had me expecting that nothing was going to happen, so when I heard the fish running over the bar I almost didn't look up. Perhaps out of some duty, or some subconscious obligation to honor the supreme effort these salmon were making, I did glance in their direction. Just visible over the seed heads crowning the brown grasses on the other side of the stream were two yellow eyes set in a narrow white face, punctuated by a black, shiny nose. Exploding out through the curtain of vegetation and onto the gravel bar, running and leaping through the twisting and gyrating salmon, there came a wolf! And then *bam!*—within seconds it had locked onto one of the fish!

In one swift and surprisingly smooth motion, it lifted the salmon from the water and carried it back to the safety of the grass. About ten minutes later it returned and put on the same show; and

then again and again. In less than an hour, that wolf had eaten five sockeye salmon weighing 5–6 pounds apiece.

I'd been watching bears fish here for a few years and not one of them had anything on this wolf's performance. This wolf was good!

When the bears fish, they run out, pounce, and pin their prey to the gravel bar with their forepaws and claws. Then they grab the fish in their mouths, if they don't eat them right there in the stream. The wolf's technique was different but just as successful. Not having the claws and forefeet of the bear, the wolf couldn't pin the fish to the bottom. Instead, the wolf used its superior speed and agility to get to exactly the right fish at exactly the right time. Instead of using its claws, the wolf grabbed the fish in its toothy mouth and clamped down, getting a firm hold (1,500 psi will do that just fine), then simply lifted the fish out of the water, and carried it back to shore to eat in dry comfort on a bed of grass.

If you fish rocky-bottomed streams and rivers, you know just how slippery and challenging they can be to negotiate. You may even own a pair of specially made felt-soled boots for doing exactly that. Wolves have the best features of those boots and more, built right into their paws.

First, wolves have big feet, with soft abrasive pads and long flexible toes that can conform to the terrain beneath them and are equipped with nails that provide additional grip and traction, working much like the cleats on sports shoes. The pads on the bottoms of their feet and toes work like the soft, nonslip soles of your wading boots by helping to grip and hold fast to wet slippery surfaces like stream bottoms and icy trails.

The track of an adult wolf is impressive. When you come across one, it instills an impression of an animal quite a bit larger than the one that left it behind. They average 3½–4 inches wide and 4½–5 inches long, and the front feet are larger than the

rear, which is uncommon in most domesticated breeds.

Some of the larger breeds of dogs can leave tracks as long as a wolf, but the hind feet are usually larger than the front. A wolf's large feet make traveling through deep snow and wet spongy tundra, mud, and sand more efficient, providing better flotation than smaller ones would. Big front feet help them to maintain their balance under challenging conditions, and also assist in making quick and accurate changes in direction while running at speed.

Wolves' big feet also make them good swimmers. The dog paddle is nothing compared with a wolf paddle. Southeast Alaska is a maze of islands interconnected by the waterways between them. If a wolf wants to get somewhere fast, the most direct route often requires crossing water. If it wants to get anywhere from an island, there is no choice but to swim for it.

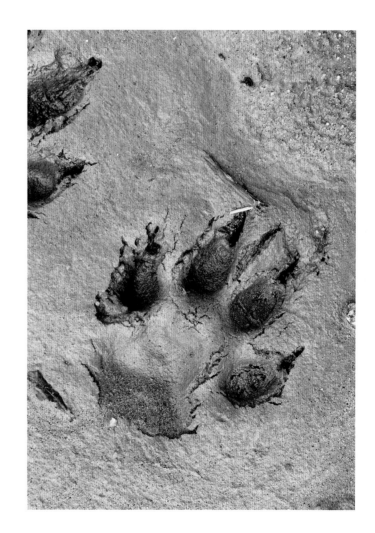

Last year, traveling by skiff to one of my favorite locations to photograph bears in the spring, I slowly motored around a point and spotted what appeared to be a small black bear swimming across the entrance to the bay. It had a seal for company tagging along behind. How strange! I lifted my binoculars to get a better view, but all that was visible was the back of its head and the tips of its rounded ears. The scene seemed odd, and indeed it was.

The seal popped up right behind the bear, which quickly spun its head to look over its shoulder. It wasn't a bear after all—it was a wolf! The narrow muzzle and yellow eyes could not be mistaken for anything else. It was making really good time, too, despite the strong current! I grabbed my camera and turned but was too slow. The wolf had just reached the shoreline and was climbing out, soaking wet and looking a bit forlorn. With a good shake, it freed itself from much of the water drenching its coat, turned back to check on the seal one last time, then headed over a tidal flat toward the forest beyond, unfazed by its swim in Alaska's chilly waters.

To distinguish the tracks of a wolf or a dog, you need to examine the patterns they leave. Dogs usually don't get out much, so when they do, they go a bit crazy. There are so many new smells that they have to go and investigate everything, so their tracks leave looping patterns in the snow (or mud or sand). Wolves, however, are outside all the time, so the tracks they leave are much more directional or straight, except perhaps when they are following a confusing scent trail. If the tracks lead back to or are associated with human tracks, you are likely looking at those left by a dog—unless, of course, the wolf is using a trail often used by humans.

Survival outdoors in the north or in the mountains during winter can be very challenging, even for a wolf. The cold burns calories, and moving

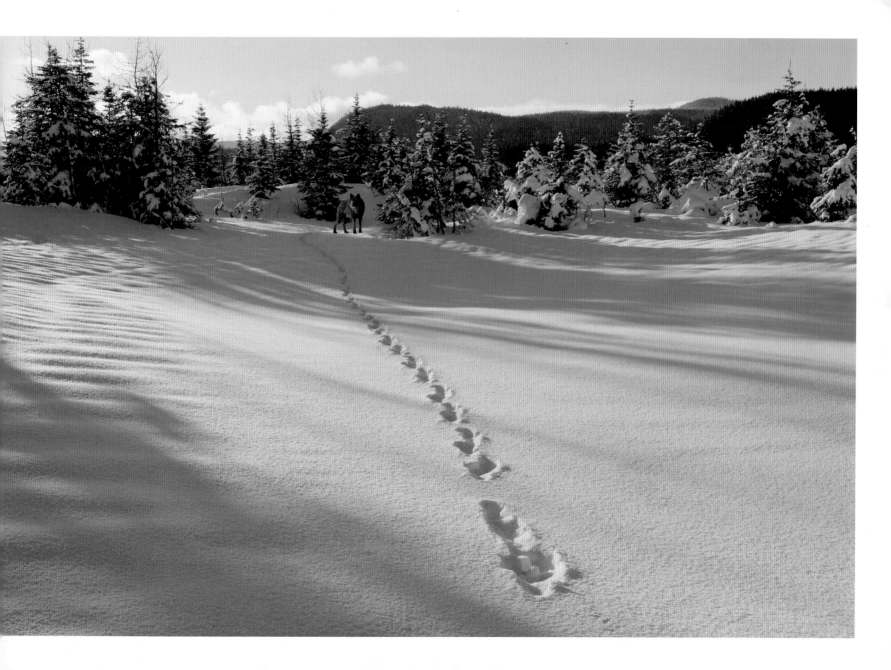

through snow rather than over hard ground is a lot more challenging, even with big feet. To help ward off the cold and to shed rain and snow, a wolf pelt has two types of fur or hair: an undercoat, topped with guard hairs. The guard hairs help to shed water and snow, and the undercoat provides insulation for warmth. Wolves shed in the spring just like domestics, and get to look pretty ragged that time of year. Their color can range from almost pure white to black and any combination in between. Darker wolves are more common in forested environments, whereas lighter colorations are more common in more open environments. The arctic wolf, which primarily lives in a landscape of snow and ice, is mostly white. These variations are due to genetic selection based on the advantages a hunter gains from camouflage and the ability to blend in with its environment.

Within a family group or pack, social dominance plays a large part in keeping physical injuries to a minimum, because hierarchy helps neutralize aggression, reduces conflict, and promotes social order. Within the group there is a social hierarchy for each sex. Social structure, integration, compliance, and teamwork are the primary benefits of living within packs. The wolves' strength is in the pack.

Being very social animals and very loyal to their established families, wolves will sometimes risk death by sacrificing themselves for the benefit of the rest. When starvation is imminent, a wolf may risk serious injury or death to bring down a prey animal it otherwise would not have pursued, or it may offer itself as bait to entice and or distract a rival pack so the rest of its family can escape. And it might throw some of its normal caution to the wind to prey on livestock or domestic pets. Anytime a wolf succumbs to the temptation to interact in the human environment, it unfortunately puts its life on the line. Humans are just like

other wolf packs: They have very little tolerance for competitors entering their territory.

## ROMEO'S TERRITORY

Being orphaned in the Dredge Lakes/Mendenhall Glacier Recreation Area is likely what saved Romeo. The habitat is rich with beaver, voles, salmon, and waterfowl; is laced with a network of trail systems; provides easy access to two additional productive watersheds; and is closed to hunting. But the key element Romeo likely found most appealing was that it provided him with the opportunity to socialize with other canids—dogs mind you, not wolves, but close enough from his viewpoint. Cousins, if you will.

The west side of Mendenhall Lake and the Nugget Creek drainage above on the east side of the valley offer substantially different habitat compared with the Dredge Lakes area. The land here slopes up from the shoreline through spruce and hemlock forest, and eventually into the alpine reaches of mountains and ridges on both sides of the lake. A hiking trail runs along the western shoreline and climbs the flank of Mount McGinnis to viewpoints that overlook the lake and glacier. On the east side, a second trail climbs from the visitor center to above Nugget Creek Falls, then up the small valley to its head, where remnant glaciers hang from the rocks above. These trails get quite a bit of people traffic, but there are a lot of small game trails that run up and down the mountains, and ridges providing access between the valley floors and the peaks above.

These areas support deer, bear, grouse, and porcupine in the forest, and mountain goats, marmots, and ptarmigan in the alpine. A few of the small streams and the much larger Montana Creek have runs of salmon. Nugget Creek has no salmon,

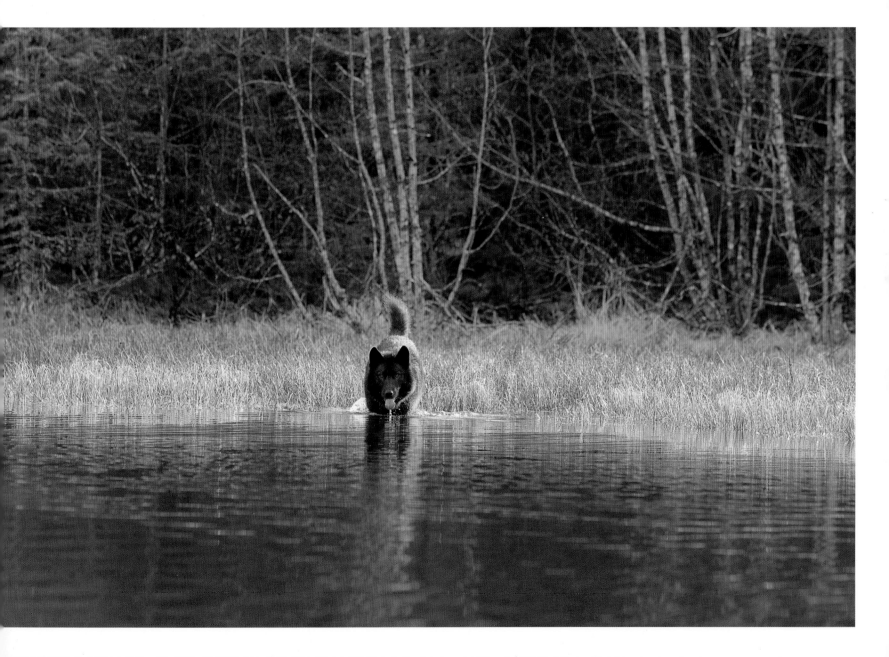

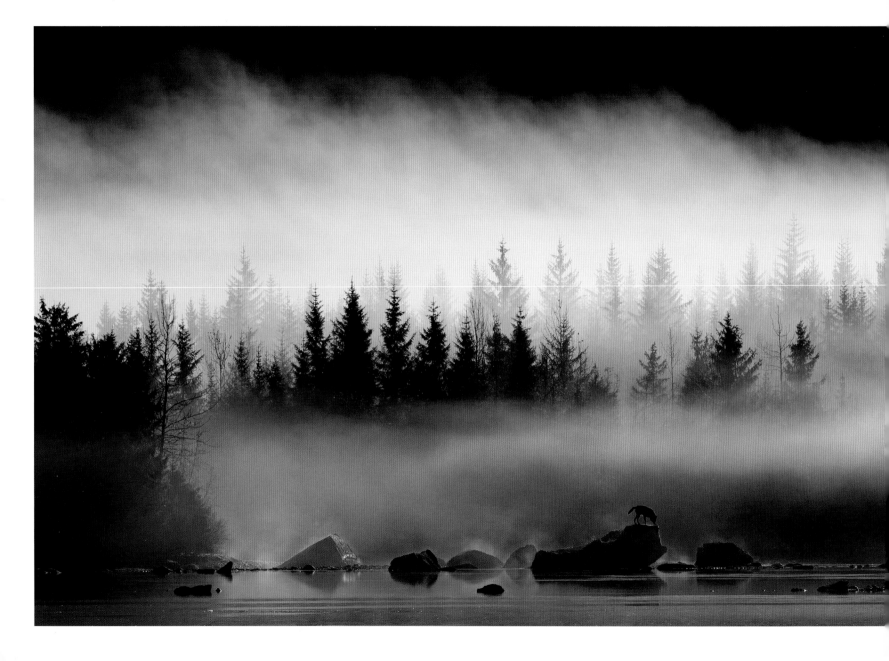

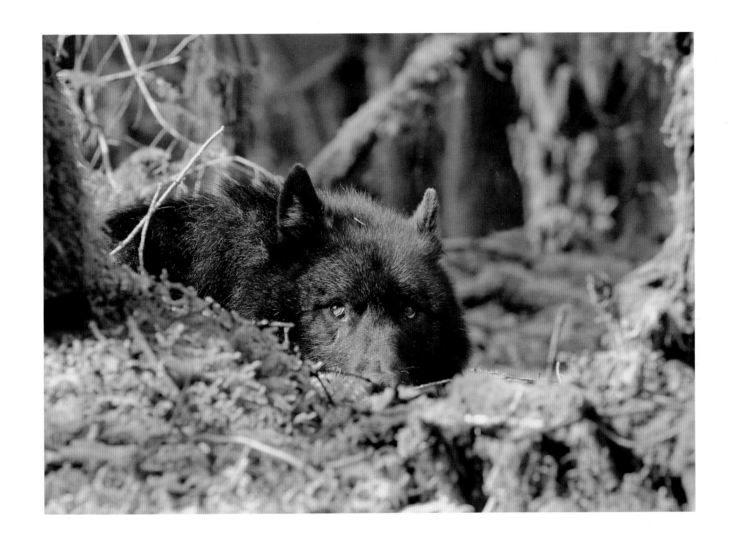

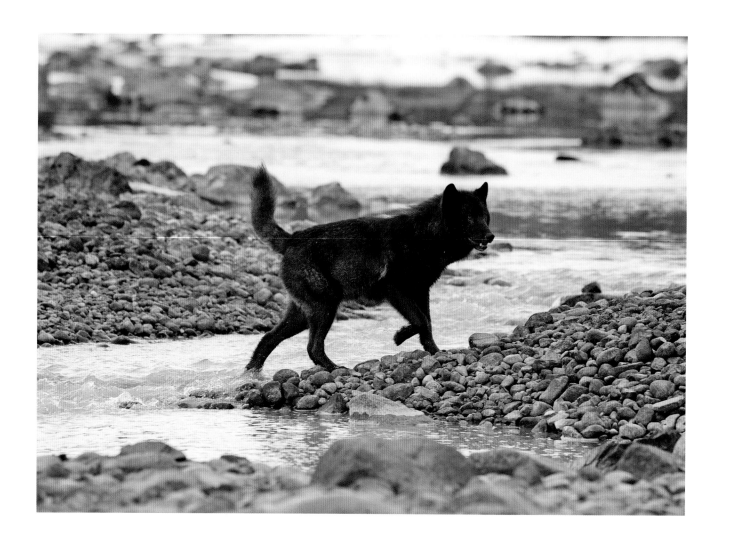

because the falls at its mouth are not passable. But the valley is rich with other resources, and provides a natural corridor into the alpine region and to lands beyond, to the south and eastward.

When you combine the habitats of the Mendenhall Recreation Area & Dredge Lakes with the Montana and Nugget Creek watersheds, you get a good selection of wildlife species and habitat types condensed into an area not much more than 30 square miles. Small, productive, and diverse, it's a perfect place for a lone wolf living off the land.

Romeo's highest priorities—food and social opportunities—were satisfied in an area where he didn't have to compete with other wolves and which was closed to hunting as well, providing a margin of safety not available elsewhere. It wasn't long before he learned he could reliably obtain at least some satisfaction from socializing with dogs. Once that behavior was established, it became key to the relationships he developed over the years, and is what drove his regular appearance every winter for many years after. A factor when considering his unique behavior is that he was free to go anywhere he wished, but he chose to live along the shores of Mendenhall Lake every winter, to the point of becoming a local celebrity.

If Romeo was about a year old when his mother was killed in April 2003, he would have been seven in April 2009. Many of the people who watched him every year expected and hoped he'd find a mate during the summer, and that together they would leave to raise a family or pack of their own, but for six consecutive winters, Romeo returned to spend time with his cousins. I was never able to figure out exactly why that attraction was so strong, or why he became so set in those ways. It was obvious that he must have received a great deal of satisfaction from these relationships, but it seemed that if there was a chance that he could have developed

a kinship with another wild wolf, it would have provided a much stronger bond simply because they could be together twenty-four hours a day. The social experiences he had with dogs lasted anywhere from a few minutes to hours at a time, but when it was time to go home, the dogs and their owners would leave, and Romeo was always left behind. I'd think that would have been very frustrating for him; regardless, he continued his wolf-dog relationships.

Maybe the opportunity to socialize with hundreds of potential playmates became a kind of a fix he couldn't resist. If he had been in a family unit or pack of wolves, the number of individuals available would have been restricted by pack size and hierarchy, and the social dynamics would have been much more rigid. Perhaps the unrestricted and extensive social opportunities he acquired along the shores of Mendenhall Lake made him feel as if he was a part of a much larger family than he ever could have been under more normal circumstances, within a pack of wolves.

After he had returned for a number of years in a row and it looked as if that behavior was going to become consistent, concern began to grow within the Alaska Department of Fish and Game and the U.S. Forest Service, the management authorities for the area. Ultimately legally responsible for any accident if one were to occur—such as the death or injury of a pet or person—they started going out with dogs and shotguns, firing rubber bullets or bean bags at Romeo, trying to condition him to avoid people and dogs. After all, he was a wild wolf, and the chance—though very slim—was always present that he could attack if provoked or threatened.

But the authorities did not meet with much success. They managed to teach Romeo only that some people were more aggressive than others, and he clearly had no trouble learning to identify

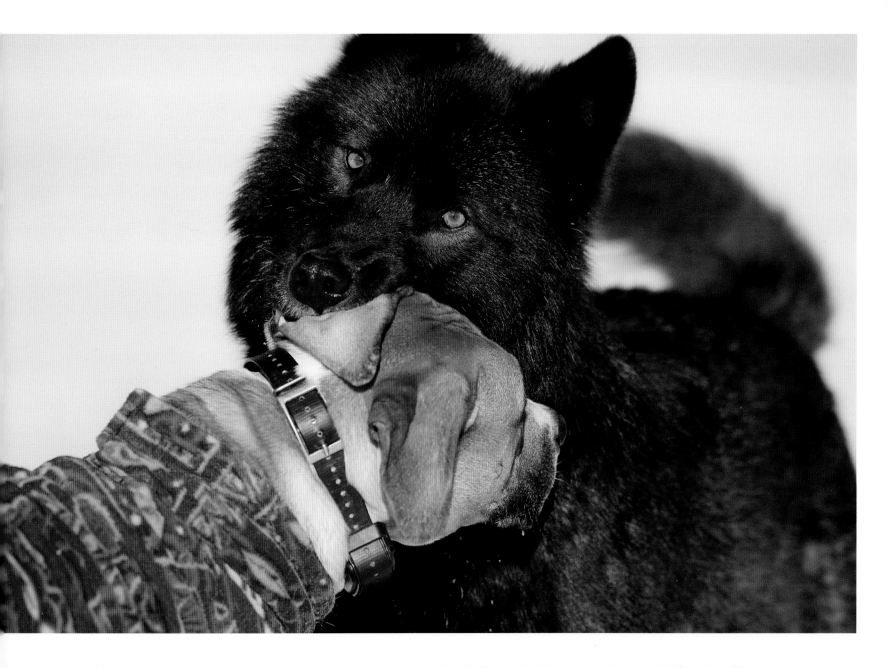

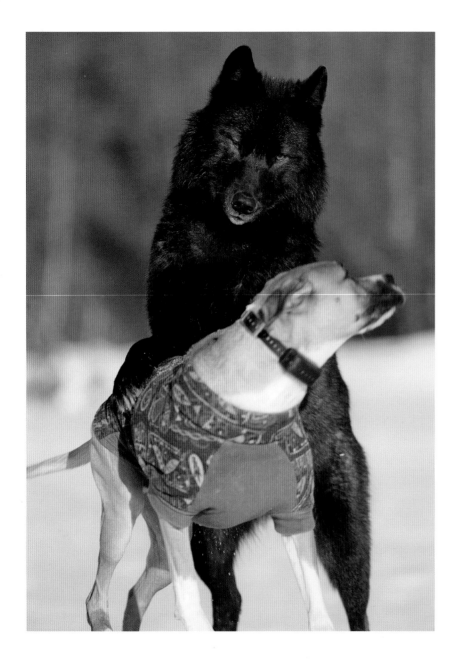

those who shot at him from those who did not. One afternoon I watched him circle around the man from Fish and Game and his dog, avoiding them entirely. The ADF&G biologist never knew Romeo had passed within 100 feet of him. The wolf had simply seen the biologist coming, recognized him, and circled around through the brush, letting the man pass along the trail and out along the shoreline. No offense to the biologist, but I had to chuckle over that for a moment or so. Romeo's behavior was so established by that time that no one was ever going to succeed in changing it. Viewing regulations were established, hoping that these would insure the safety of people and their pets, and thus the wolf as well. The regulations stated that people were not to approach closer than 100 yards to the wolf, and if, instead, he came too close, the pets had to be placed on a leash.

The problem was that if someone was walking their dogs, even on a leash, he could approach them and follow along, as long as he wished. It was impossible to outrun him, and he was not really frightened by people, so other than leashing their dogs, there really was not much else owners could do. If Romeo wanted to approach, he was going to, regulations or no regulations. Because the area was so popular, even if everyone complied with the regulations, his behavior would not change. The social opportunities available to him around the lake during winter months had become as vital to his health as food.

When attempting to judge any potential threats his presence may have presented, we need to remember that aggression is always the last resort for wild animals. Even a nonlethal injury can easily lead to death. An infection, a broken jaw, a damaged limb—anything that can reduce the animal's effectiveness as a predator or weaken its immune system—can become lethal with time or under stress.

Wild animals, especially high-level predators, avoid physical aggression. They risk enough just trying to survive; to risk more is foolish. Domesticated animals do not assume the same risks as wild ones, and their reactions are consequently different. For many reasons, domesticated animals can have aggressive tendencies that wild ones do not. In the wild, unprovoked aggression was bred out of most populations, simply because animals with a genetic predisposition toward violence tended not to survive over the long run.

Domestic animals, especially dogs, have their basic needs taken care of because we provide for them, we protect them, and we even doctor them. Worse, we even breed them to enhance those

traits for our protection, to further our objectives, or simply for our entertainment. This is not to say that dogs cannot love, and be loyal pets; they can. But they also may exhibit aggressive behavior much more rapidly and under a wider variety of circumstances than wolves in the wild. Captive wolves are another story; they encounter the same distortions of nature as domestic pets, with often predictable results.

I have known many wonderful, well-behaved, easy-going, loving, and respectful dogs. But I have also run across quite a few ill-tempered, aggressive, and even vicious ones that exhibited such behavior for no apparent reason other than to assert themselves. I have spent half a century with wild predators in Alaska—with bears, wolves, killer whales, and others—but I have never once received that treatment from a wild animal. Let me give some examples.

One gloomy winter afternoon, as I was heading back to the trailhead, that familiar whine of his caught my attention. Looking up, I watched as Romeo trotted up to a small terrierlike dog that had run far ahead of its owner (who was still a ways behind) along the west side shoreline. The small dog continued to bark at Romeo, and when Romeo lowered his head in the common play posture, the little dog jumped forward and bit him on the nose. Not only that—it hung on!

As Romeo raised his head, all four of the dog's feet left the ground, and with a quick shake, the assailant fell to the ground on its back, looking up as if it expected the worse to come. Romeo gently laid a front paw on its upturned belly, cocked his head at an angle, and looked it in the eyes. Then he lifted his paw, releasing the small dog, which immediately ran yapping back to its owner.

On another occasion I had taken a break for

some water when I noticed a group of people come around a turn in the shoreline. It was a fairly large group: three or four people and some dogs.

Romeo had been resting in the sun a few hundred yards away, but now was ready for some play. He stood up, yawned and stretched, then started over toward the group. The dogs ran out to greet him, and soon the whole bunch was involved in a playful game of tag. By now, the group of dogs had moved about 200 yards from their owners, and a small pug was out in the lead with Romeo.

After a few minutes the owners called their dogs, most of which at least stopped running or started back, except the pug. Romeo was having a great time. He did not want to stop playing. When the pug stopped and looked back toward its owner, Romeo reached down and gently grabbed it by the scruff of the neck, lifted it off the ground with ease, turned, and started to run off with it. The

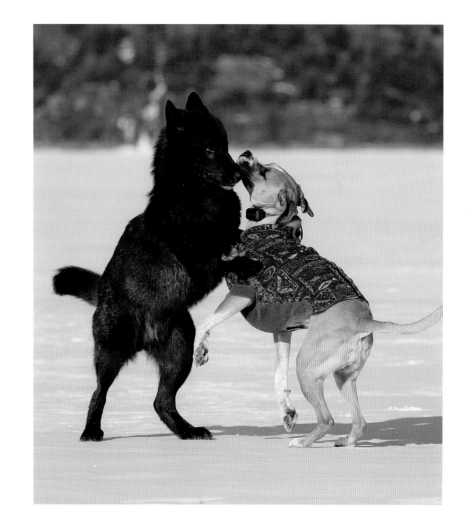

owner now became quite concerned and started yelling. Romeo dropped his little playmate unhurt, on the snow, and grudgingly walked off.

This episode was reported in both local and a few national newspapers, and almost every writer suggested that Romeo was running off with the small dog to eat it, but that was as far from the truth as could be. It made for a more exciting read, I suppose, but there was no more to it than that. His true intentions were to prolong the social experience by taking the small dog, which he could easily lift and carry without hurting it, away from the human who would ultimately end their playtime by taking the dog and going home.

This was his social reality, and it frustrated him greatly, especially in the earlier years. I watched many departures where he would sit and cry (whine) for those leaving to come back and hang out for a while longer. He was smart enough to know that people were the reason his domesticated friends left at the end of the day, the hour, whatever. And it was obvious he thought if he could just succeed in getting a playmate away from those darn people, then he might have a chance at a more fulfilling relationship!

I'm positive that was his intention. If he had wanted to eat that little dog, he would have killed it in a few brief seconds before he ran off with it, just to make sure it did not get away. I would add that this scenario occurred more than once, with no injury to the small dogs. One should also consider the fact that less dominant wolves in a pack are often assigned the job of babysitting and caring for any pups in the group. Romeo was older, and had lost his entire family, so perhaps he was reacting to some simple drive to care for the young. This small dog, like any young wolf pup, would have triggered a protective response.

Fortunately, he did not get away with the pugs in either case, because winter nights in Alaska get cold, often with temperatures dropping to less than 10 degrees Fahrenheit, and a little short-haired pug would really have been in trouble at that point —from hypothermia, not consumption by a wolf!

If Romeo could not find a domestic to play with, he would often just follow along behind people and dogs, acting as if he was part of the group. Sometimes he would take the lead, if he correctly judged where they were headed—which, if they were on the ski trail and the snow was deep everywhere else, was not too difficult.

Often when he approached an animal that he wanted to play with, he would assume a low stance during his close approach, and then bound or jump, landing with his front legs splayed out in front and his head lowered, looking up inquisitively at his potential playmate.

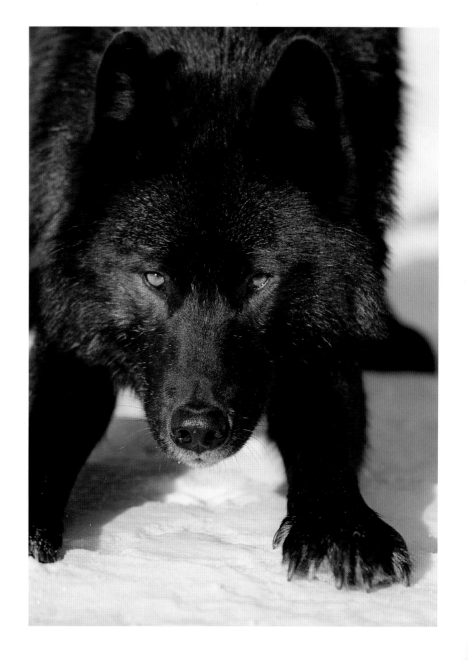

## WATCHING ROMEO

During the years that I spent photographing Romeo, I was lucky to have many encounters with him that gave me some insight into his personality, specifically, as well as the nature of wolves in general. Some of the most memorable occurred when the lake was devoid of human presence—when it was just me and the wolf.

On one occasion, it was very cold and no one was out at the lake—no people, no dogs. The wind was coming off the glacier and packing the snow into substantial drifts. The wind chill was -20 degrees Fahrenheit or lower. I scanned the lake and shoreline until I spotted a small black shape that seemed to move slightly once in a while. But it was too far off through blowing snow to tell if it was the black wolf, or just a moving shadow.

Deciding I needed some fresh air, even if it was a bit chilly, I headed out across the lake for a better look. About halfway across, the wind and blowing snow became so intense, I changed course a bit, and headed toward the river to put the wind at my back. The shoreline soon became obscured, but because I was more than halfway there, I didn't want to turn back, cold or not. After about 5 minutes, the wind started to die off and, as the snow settled, the shoreline materialized.

And as I turned back toward the northeast, I could see Romeo lying in a drift of snow, seemingly content. Digging into my pack for my heavy down jacket, I decided to lie down out of the wind behind a large berm of snow and watch him for a while. The solitude was rewarding, and once out of the wind, the cold was not too bad. The only sound was the rustle and tinkle of icy snow crystals blowing across the vast winter landscape. As a cloud moved in and cut the sun's warmth, my wolf friend stood up, stretched, and walked off through the snow. Instead of following, I made my

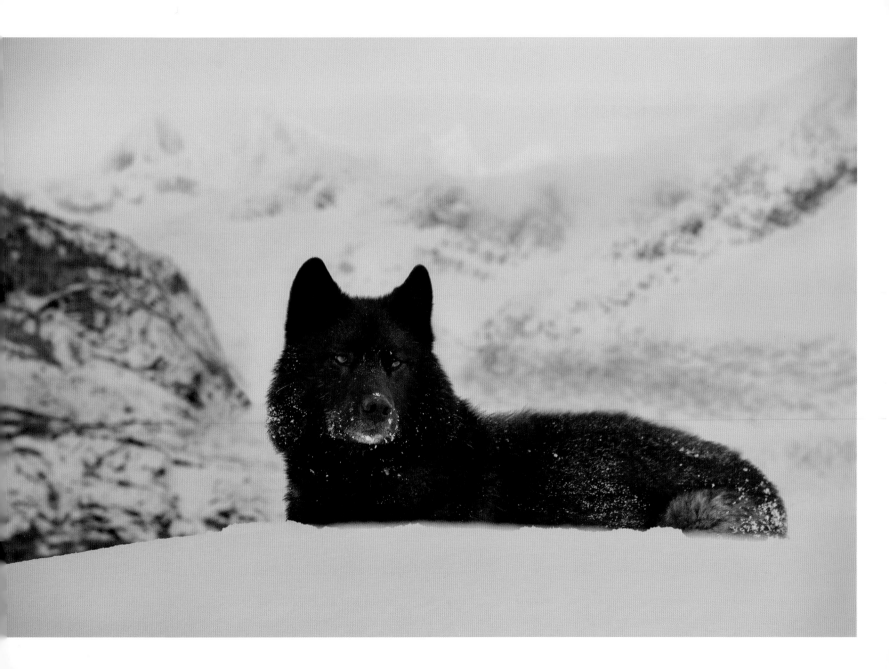

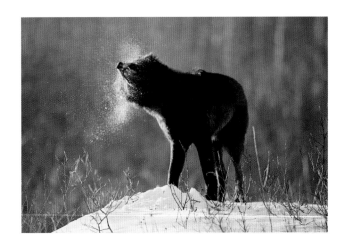 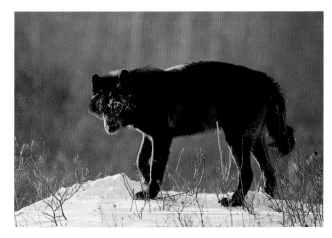

way back to the warmth of my truck and eventually home.

It continued to snow that night, and setting out the next morning, I found Romeo in the same area I had left him the evening before. The deep snow made for nice skiing, but it also provided cover for one of his primary food items: voles. I decided to cut around a brushy area he had entered, out to the shoreline, hoping he would exit the brush and return in my direction. And luck was with me,

because that is just what he did. As he walked up on a drift of snow-covered brush and grass, he suddenly stopped. Rocking his head back and forth, from side to side, he seemed to be listening for something. Then up he went, leaping straight off the snow into the air and pouncing back down, jamming his face deep into the snow as far as he could, hoping to reach down far enough to catch some lunch.

Again and again, he tried. Sometimes he would

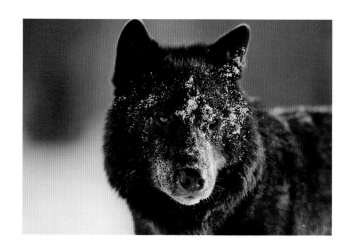

disappear all the way to his shoulders. He must have been listening to a vole moving within its grassy tunnel, way below the snow. As entertaining as they were for me to watch, his antics did not seem to be producing the results he had hoped for, so he moved on in search of new opportunity.

Not long after the sun went down over the ridge, the surrounding peaks on either side of the glacier glowed pink in the dusk. Having a beautiful black wolf in such a scene was enough incentive to keep me there on my belly in the snow, at least until my legs felt like wood.

A few days later, the wind died down, but it was still clear and cold. Looking around for my friend with the hairy ruff, I could not find him anywhere, so I decided to ski across the lake to the face of the glacier and see what had been happening since the last time I was there. Even though everything is frozen solid, the face of the glacier still calves throughout the winter, and when it does, the sheered, blue-ice face that is revealed is striking in contrast to the white, winter snow. After exploring the face for a while and taking a few photos, I heard a wolf howl in the distance—back the way I had come, of course! The sun was getting very low, so I put my gear away and headed back. As I rounded a rocky point, the distinctive silhouette of a large black wolf emerged from a bank of ice fog forming along the shoreline. He was heading toward the middle of the lake, directly toward a

woman on skis with her pet canine running along behind.

She called the dog over, put it on its leash, and then continued on toward the parking lot and the wolf. Romeo and the dog glanced at each other longingly, but the skier continued on, leaving the black wolf without a playmate. He stood there for a few seconds, and then sat down in the snow to watch, as the sun began to drop behind the ridge beyond. Quickly, I shrugged off my pack and scrambled to get a few quick photos, before the orange fog faded to gray. Within minutes, the only light left was reflected in the sky overhead.

Whenever I went out hoping to acquire a few more photos of Romeo, it seemed that, more often than not, the best opportunities were fleeting and easily missed. There were many times when I would never find him, or find only signs of him having been in the area previously. Sometimes sign would be so fresh, I expected him to step

out from the cover of a thick stand of spruce, or a tangled edge of alder and willow. Sometimes I would feel as if he was watching . . . and perhaps he was. He was the master of that land, not I.

There were times when he would grace me with his presence for hours at a time. but even then, the best photographic opportunities would be short-lived. A least in part, I suppose, that is why I kept at it for so long, trying to capture those moments when his personality was most evident to the camera: because those special moments are all you have, and want.

Later in the year, on a warm but overcast spring afternoon, when drifts of old snow still lingered along the riverbanks and new snow still fell in the mountains above, I walked upstream to where the river flows out of Mendenhall Lake. A light breeze was flowing down over the glacier from the ice field above, and across the lake to where I stood. Stopping to get a drink of water and to shed a

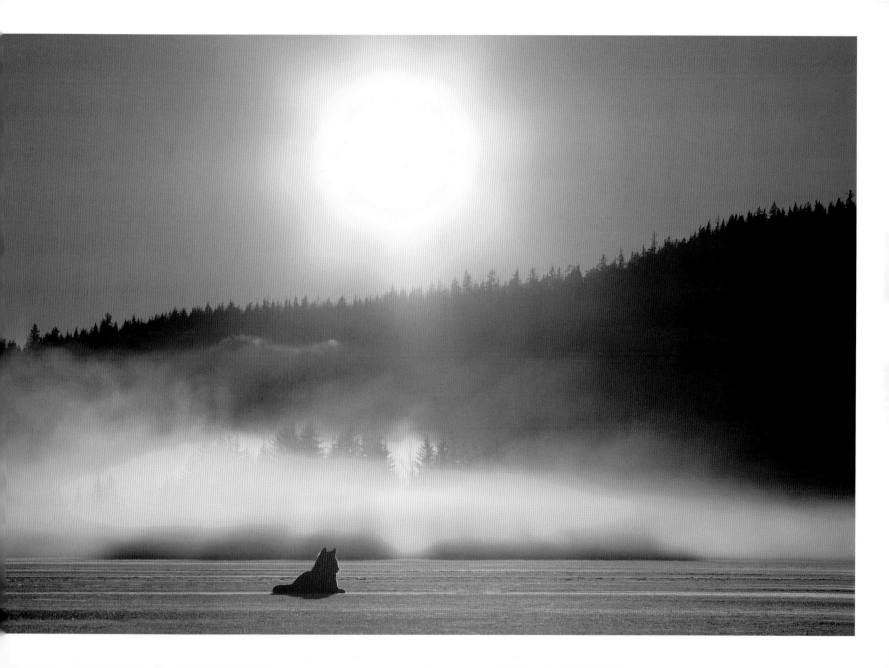

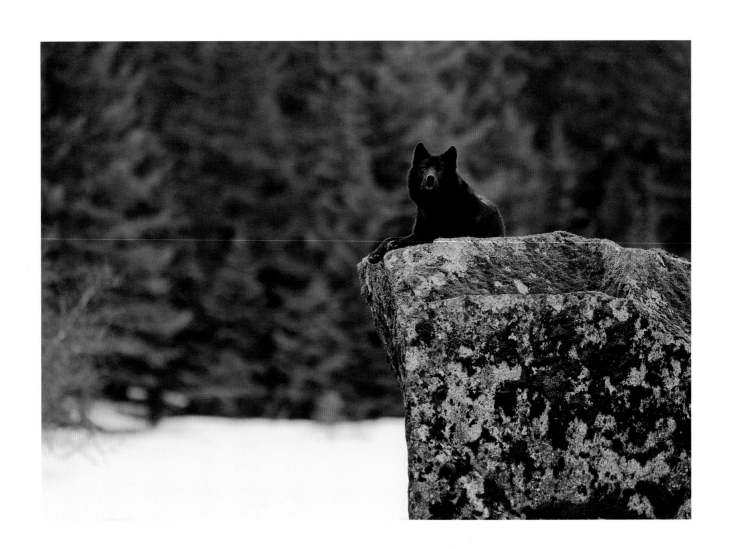

layer or two in the unexpected warmth of the day, I took off my pack and sat down on the bank along the shoreline. Just at the edge of my field of vision, a bit of movement caught my eye, and as I looked up, there was Romeo, sitting on top of a huge rock out in the middle of the river. He must have been lying down out of sight on top of the flat-topped boulder, and sat up when he saw me.

I had never seen him in there before, and did not think he would stick around for long knowing that I was watching. I had been taking landscape photos on the way in, and I needed to change the lens to a longer telephoto in order to get the image I desired. Nearly dropping my water bottle in the mucky gray glacial silt at my feet, I fumbled around in my pack for the right lens. Much to my relief, Romeo stood, walked around, and changed positions a few times, as if trying to find the best combination of view and comfort on the big moss-covered rock. My presence did not seem to bother him in the least. But the light was beginning to fade, and the sun was finally setting somewhere behind the clouds. Luck was with me, though, because there was just enough time left to get a few photos, before the approaching night would shut out the light and warmth of the day. And that's where I left Romeo: still sitting on his perch above the river, as darkness fell.

That wasn't the only time I found him perched high up, on that boulder. The next winter I had gotten out early, before the sun was up, to catch the morning light as it came over the ridge, illuminating the wonderfully deep and fluffy new snowfall along the upper river. After making quite a few photos, it was time to go visit the bushes. I left my gear in the snow and walked over to do my business. I wasn't really paying much attention to what was happening, thinking instead of where I wanted to go next. Heading back to my pack, I took one last look around, and there he was, coming down the

edge of the river toward me. The problem was that my pack with my gear was still about 20 feet away.

He stopped and turned, staring across the river where a dog had just barked, giving me just enough time to make a move for my pack, grab a camera, and get a few shots. Then another dog barked on the other side of the trees behind us, and he headed off into the campground, where he figured his chances were better than they were with me. Creatures on two legs weren't on his social agenda that day!

Moving on, I worked my way upriver, taking photos of the landscape as I went. I did not expect to see Romeo again, but when I reached the head of the river, where it flows out of the lake, I heard a whine just like a dog makes when it wants to go out. There he was again, on top of the same boulder on which I had seen him perched the previous spring. This time his attention was riveted on some dogs that were coming up the opposite bank. He stood there for a few seconds and then leaped off the snow-encrusted boulder, trotted down along the shoreline, and crossed where the water was only a foot or so deep. Unlike the previous time, when my camera was deep in my pack, this time it was ready, hanging around my neck, and he was so close there was no need for a telephoto lens. But the window of opportunity was very narrow, and with my adrenalin running, I had just enough time to grab a few quick frames.

There are a number of these large boulders deposited in various locations around the shorelines of Mendenhall Lake, sitting on the open ground, along the lakeshore, in the river, even back in the forest, appearing as if they had fallen mysteriously from the sky—which, of course, they did not. As the glacier retreated, having previously scoured the landscape down to the bedrock, like a huge earthmover, it also left a lot of silt, sand, gravel, and small rocks behind. These piles of lighter debris,

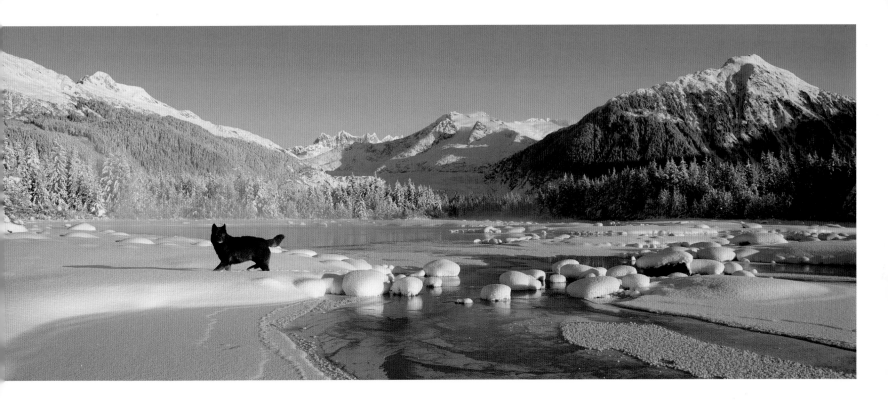

called moraines, created structure within this land-scape, and created the paths and ponds where the waters flowed and collected.

Back in the mountains, huge rocks and boulders would occasionally fall or get dislodged from the cliffs above, landing on these massive conveyer belts of ice, which moved these granite behemoths downhill as they advanced. Then, when the glaciers retreated, moving back into the mountains as they melted, they got left wherever they happened to be sitting. Because these glaciers are still in retreat, these giant rocks still sit there today; the perfect sunny places to relax, off the wet ground, where nothing can sneak up on you, and

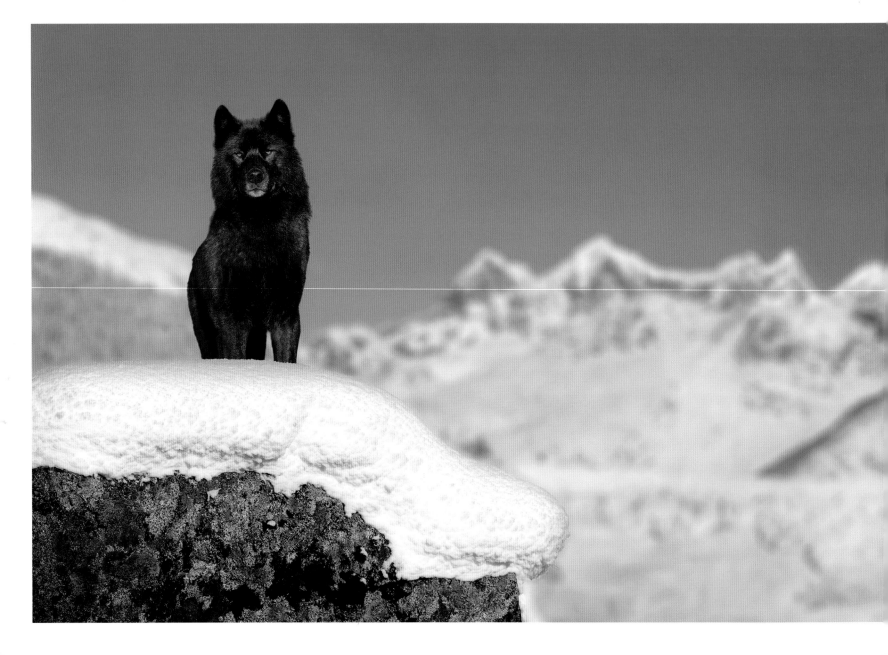

making perfect vantage points for hikers to take in the view, or for wolves to examine scents blowing on the breeze.

One afternoon as the sun was beginning to color the sky pink and gold, a friend and I were headed back toward the parking lot, with Romeo lopping along a considerable distance out in front, playing his role as leader of the pack. We had been walking along a few hundred yards behind him, not really paying too much attention, then I looked up to check on his whereabouts and discovered he had vanished. We kept walking for a bit and soon stopped to scan the shoreline, when he suddenly appeared on top of a large boulder to our left. He had leaped to the top in a single bound, a distance of about 6 vertical feet, with little apparent effort.

We had lost track of him simply because he had been standing out of sight behind the huge rock. Shrugging my pack off as quickly as I could, I pulled my camera out. The idea presented by the scene

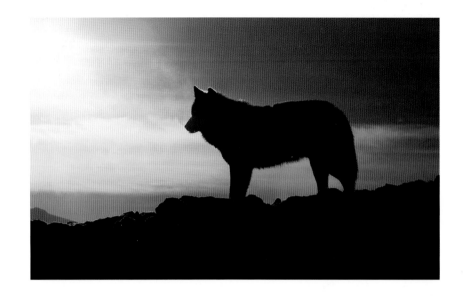

was inspiring, but he was moving around, making it difficult to find a pleasing composition. And my frustration was mounting, because I knew the opportunity would not last long. This time the lens I had on the camera was too long, providing a closer perspective than I wanted, but there was no time to change lenses. I just had to go with whatever I could get, and be happy with that and a few photos of him silhouetted against the sunset sky. It was humbling to know that he could just walk up to one of these boulders and leap up effortlessly from a standstill!

On another afternoon, while exploring Dredge Lakes, I was about to give up when I heard a howl on the far side of a copse of trees. I walked around quietly, and found him lying on the edge of a slough full of meltwater. The sun was going down, and the light was no good from my perspective, so I decided to try and move around him to the other side. But there was no way to go any farther. The water was too deep, and the ice was no longer safe. So I just sat down and watched. After a bit he got up, walked over to the edge, got a drink, and then, without any warning, sprang into the air and sailed 20 feet over the slough, leaving me wishing I had had my camera in my hands instead of my hands in my pockets!

A haven for a lone wolf, the Dredge Lakes area (Mendenhall Glacier Recreation Area) is bordered on one side by the river and is composed of small streams, sloughs, ponds, and small lakes interspersed with moraines. The forest is alder, cottonwood, and willow, with spruce and some hemlock as well. The interconnected waterways and abundant hardwoods provide great habitat for beaver, salmon, and waterfowl. The grassy meadows and sedge-covered shorelines support good populations of hare, mice and voles. And in the winter when the waterways are frozen, they make great highways for Nordic skiers, snowshoers, and wolves.

A friend and I had been following Romeo's tracks through the snow along a series of moraines, and had just climbed down a few feet to the water's edge to test the ice on a slough where he had apparently recently crossed. Spring was in the air, and things had begun to warm up. The ice can be tricky at that time of year. Hesitantly, we began walking down one of these corridors, holding close to the dead alders near shore. The ice was at least 6 inches thick, but its structure might have been compromised by the wet weather the week before.

And these sloughs often fail to freeze up as hard as other waters.

Working our way through the alders, we were just about to come around a bend when, peering through the snowy leafless branches, we spotted our friend, the wolf. He was leaping up and down on the ice in the middle of the frozen slough! Lowering his head to where his nose almost touched the ice, he would suddenly leap vertically straight up into the air. I had no idea what exactly was going through his head, but it was very similar to the gyrations he performed while hunting mice or voles. However, that certainly was not his objective on the ice that day, and neither was it the best place to test the strength of the ice underfoot, because the middle of the slough was at least 10 feet deep! The behavior was so peculiar I almost forgot to get out my camera. As soon as I got a few photos, he ran off toward some barking dogs on one of the ski trails nearby.

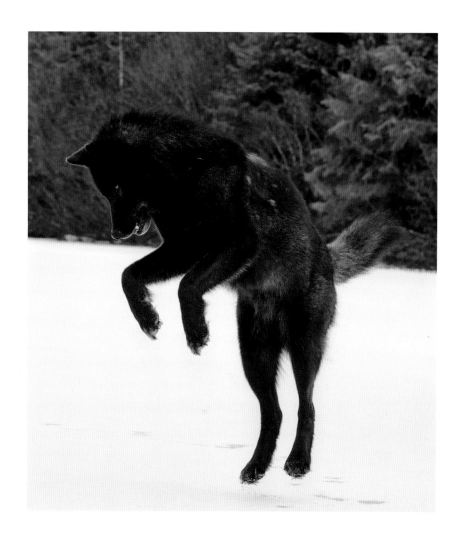

## WINTER TRACKS

The winter of 2008 began with a cold freeze that turned the surface of Mendenhall Lake into a vast, polished slab of ice. One day, when I was out on the lake taking photos of icebergs frozen in the surface, I looked up and noticed Romeo walking the shoreline. Every once in a while he would come down to the edge of the ice, place one foot on it, then retreat back to the beach and continue on. After he had done this about three or four times, I began to wonder why he would not come out on the ice, because it was more than 10 inches thick. As I watched, he came to where a small stream ran out of the forest, crossed the beach, and flowed into the lake. At most, it was only a foot or so deep, but there were a few spots of open water. Standing on the bank at the edge of the stream, he first gingerly placed one forefoot onto the ice, and when that held, he tried both his front feet. Then he tried a small pounce, landing on both front feet. The strength of the ice had passed all these tests, yet he still did not feel confident. As a final test, he reared up to his full height, stood on his hind legs with his forefeet held over his head, and came down with as much force as he could. The ice still held, and, comfortable with its reliability, Romeo finally walked across.

Watching this made me wonder if he had recently experienced a mishap, and received an unexpected bath in the freezing cold waters. I had never seen him go through so much effort to test the ice before, and had often seen him walking on ice I would not have trusted. Or maybe it was because the ice was so transparent? Almost as clear as glass, it was difficult to judge how thick it really was. I have to admit that that same day I had pulled an ice screw from my pack and drilled quite a few test holes, to put my own concerns at ease. He never did come out onto the lake that

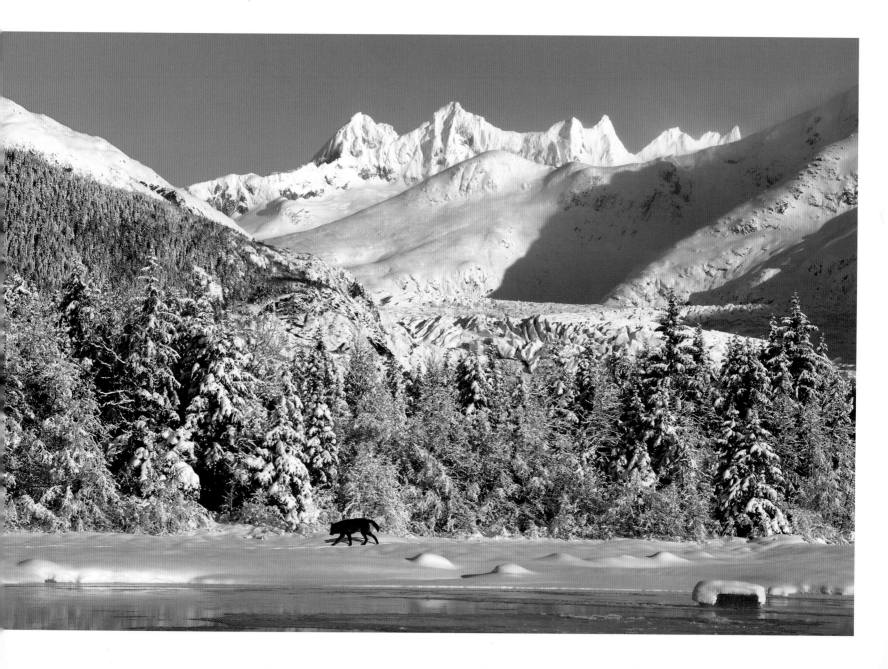

afternoon, preferring to soak up the warmth of the sun from the safety of the dry, sandy beaches.

Later that same winter, I was returning from a day's snowshoeing around Dredge Lakes, when I heard some dogs barking followed by the unmistakable sound of Romeo's whine greeting them. It sounded like they were on the next pond over, so I crossed through the short stretch of forest separating us. The owner was throwing sticks for the dogs, while Romeo lay in the snow at the edge of the forest watching. The younger dog was not very good at finding the sticks its owner was throwing, especially when they disappeared into the deep white fluff, but because they were playing on the frozen surface of a beaver pond, there were lots of dead, water-logged branches of alder and willow poking up through the ice along the shoreline.

As the dams beavers build grow larger, the waters behind them get deeper, spreading into areas where live trees are growing. After a few seasons, the live trees die, leaving the main trunks still standing. When this particular dog could not find the stick thrown to it, it would instead try to break off one of the convenient options poking up through the ice, and actually managed to do so successfully a number of times. Occasionally it would take on one much too large and would end up having to abandon it for another. After a while, the owner decided it was time to move on, and they walked off down one of the many trails.

Romeo got up to follow. But before heading out, he glanced over toward the area where the deadwood was exposed, bounded over through the snow, sniffed around a bit, and then suddenly chomped down on one of the dead alders the dog could not break free. Frustrated, he let go, shook his head, and then grabbed hold a second time, raking his teeth up and down the trunk. Those few extra seconds were just what I needed to get my camera out of my pack, up to my face, and adjust

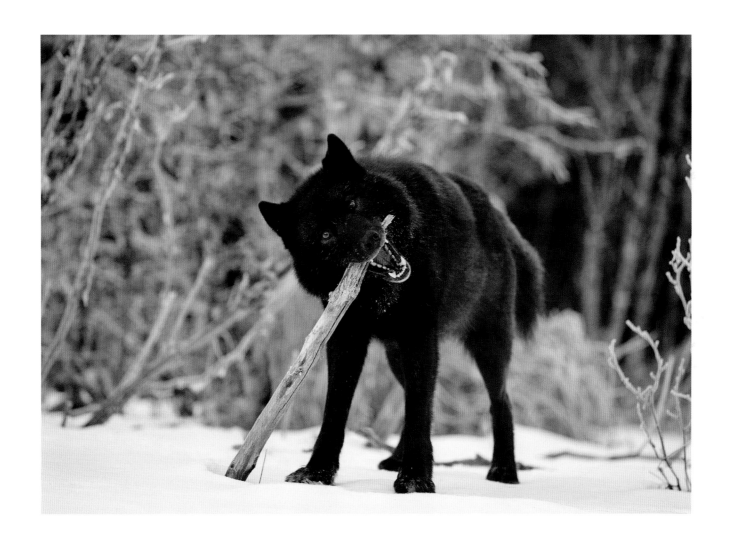

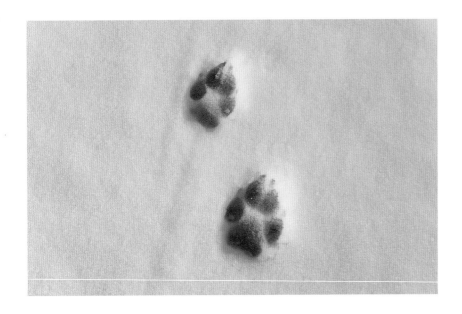

the zoom lens to frame Romeo in the best possible composition, considering the time constraints of the moment. The sun once again had just gone behind a low ridge to the west, and darkness would be upon us quickly. As he walked off and I took my eye away from the viewfinder, moving the cold camera body from my face to its place in my pack on the snow, I felt a sensation similar to that which one experiences when removing a Band-Aid. Looking down, I could see a piece of skin from

my cheek just below my eye that was stuck to the cold steel of the camera back. I had not noticed the cold, but touching my cheek I could see my fingers come away red with blood.

Winter was the most dependable time to find Romeo, so that was when I spent the most effort looking for him. On one of those winter treks along the lake's shoreline, I had stopped to watch him through a spotting scope as he rested in the snow. It was late on a crisp winter afternoon, and the sun was just above the trees over the campground behind him. His breath was backlit by the setting sun and looked like orange vapor in the cold air. At the time I was too far away to get any photos, so I put that one on my wish list.

A few days later the afternoon sun lit up my office as the clouds broke, and I couldn't resist the temptation to get out for a walk. Grabbing my gear, I headed to the lake. A friend I had talked with a day before said he had seen Romeo over by

the campground, so I decided to head up the river on the east side, so the sun would be at my back if I was lucky enough to find him by the lakeside.

I saw no new tracks on the way up to the lake nor heard any barks or howls indicating his presence, so I decided to take a break, sit down in the sun, and just listen to my surroundings. Traveling over icy terrain is a noisy business. Snowshoes, skis, and cleats all tend to drown out the gentler and more subtle sounds that can provide telling clues to what is happening around you. The sun was getting pretty low, Romeo had not shown himself, and things were pretty quiet.

Sitting there in the sun, I thought that even if I did not get a chance at that wish-list photo, at least this was a nice way to end the afternoon. Then, as I stood up and shouldered my pack, I heard a howl over in the campground a few hundred yards across the lake. Some dogs began to bark, some people began yelling commands, and suddenly Romeo emerged from the trees and out of the shadows along the far shoreline. I sat there watching, trying unsuccessfully to prompt him via telepathy to come out into the light. It did not work.

He continued walking inside the shadows by the water's edge. But at least he was headed in my direction, toward the outlet, where the river ran out of the lake. I was hoping he would stay along the shoreline and then start down the river. It looked like he might, so I shouldered my pack and followed him from the opposite shore. His course was leading him toward an open area, and raising my hopes. Then he stepped right up to the edge, but still in shadow, and let loose a howl. He was so close to being in the perfect spot that with just another step or two he would be where I wanted him. I dropped down to my knees in the snow, got my camera out, and framed him in the viewfinder. But he had stopped howling, and it looked like he was going to walk back into the trees. I held my breath.

Taking a few steps forward, he tipped his head back and flattened his ears. Lifting his nose in the air, he let out a mournful cry that cut through the silence. The shutter on my camera sounded like a sewing machine, as sunset-colored vapor poured into the still air from deep within his lungs. As that last howl faded, he turned and glanced back across the river in my direction, as if to say, "Happy now?"

As winter began to give way to spring that year, Romeo could often be found hanging around on the west side of the lake—if not down along the shoreline, then up in the forest, on the side of McGinnis. He seemed to follow the snow as it receded up the mountainside. Not having spent much time up there in the past, I was surprised at the network of trails and the number of small ponds and streams that provided sustenance and refuge to deer, black bear, blue grouse, porcupine, and even puddle ducks of various species. I do not

know how many times I have flown over that ridge, coming and going from the ice field above, but I had never noticed these ponds from the air. How the ducks found them, I will never know!

Mountain goats foraged along the steep rock faces close to the forested mountainside, marmots whistled in the alpine, and a few beaver had built dams along the shoreline of the lake below. It seemed like it would make productive hunting territory for a wolf, which could use the cover of the forest to its advantage. Songbirds sang their mating songs, while small streams cascaded down the mountain making their own music. Occasionally the thunderous roar of an avalanche interrupted these melodies, as melting snow and ice broke free, giving way to nothing as it devoured whatever happened to be in its path.

Green leaves were emerging from buds on the willows and alder, but the forest floor was still covered with brown leaves. That is what made

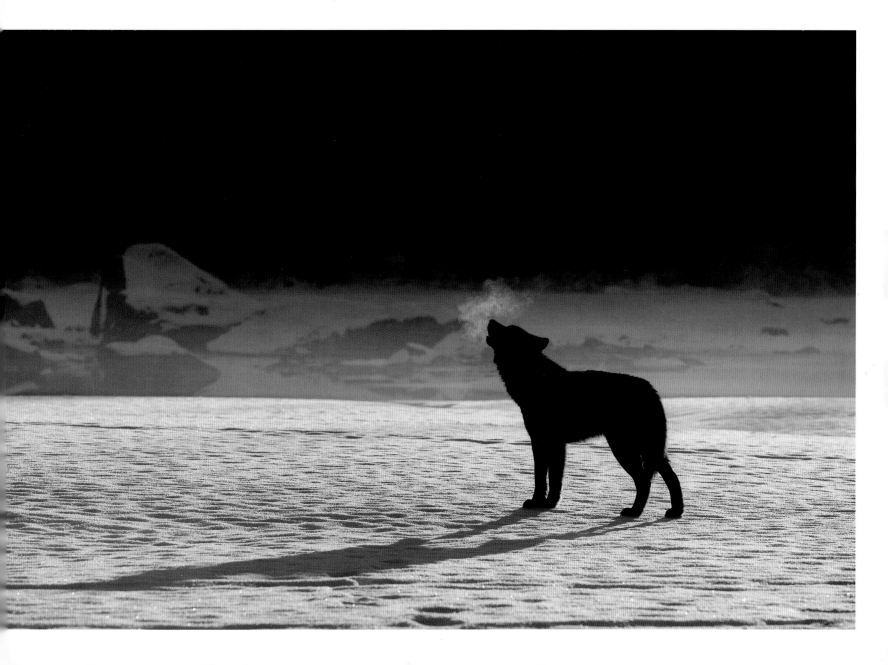

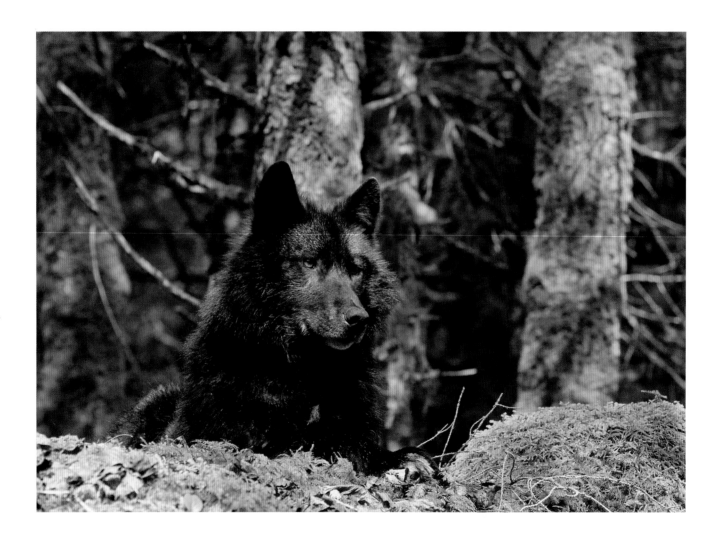

it so easy to spot the feathers scattered on the bank about a hundred feet away. Picking my way through some brushy undergrowth around to the opposite side of the quiet pond, it was soon obvious that the mallard duck that had found refuge on this tiny body of water would not be using it any longer. Not much remained of the bird except a few iridescent feathers, but they were enough to identify the species.

While hiking the same mountainside one morning a week later, I heard a distinctive yelp. Looking up, I spotted Romeo standing a few hundred feet away in the forest. He seemed to be acting kind of funny, indecisive; he then quickly disappeared around the bowl of a large cottonwood. Waiting for him to reappear, I was disappointed. He had melted away, as if he had dissolved into some black hole or void. I went over to where I'd last seen him and found the still bleeding corpse of a porcupine, which he must have just caught minutes before my arrival. The skull was crushed, and there was a 3-inch hole in the neck under the animal's jaw through which its heart and liver had been removed, leaving everything else seemingly intact. Previously I had found a few carcasses similar to this, and had wondered what animal had managed to catch them. Now I knew. And apparently he had learned to do this without getting injured by the sharp quills that nearly cover a porcupine's entire body and often end up in the paws and faces of dogs that have not yet learned to let them be. Feeling somewhat guilty for having disturbed his morning meal, I headed back down the hillside and toward the main trail.

In southeast Alaska, the arrival of spring is marked by shaking away the confines of winter. The reliable parade of domestic dogs thins out along the shorelines of Mendenhall Lake. The attraction for skiers and skaters has gone with the ice, until next winter, and as the snowpack begins

to melt, the open spaces along its shoreline begin to disappear as well. People have more options for exercising their pets and begin taking them to explore new areas. For a wolf that needs to put on a few pounds after a lean winter, lots of new hunting opportunities are becoming available. So Romeo too begins to move on, broadening his horizons, as his visits to the lakeshore become less frequent.

Occasionally I catch glimpses of him, while I'm walking the trails or flying over alpine ridges in pursuit of other seasonal objectives during the summer, but for the most part Romeo is not the dependable presence that he is during the winter months. Then, as the green of summer begins again to fade to the yellow, gold, and brown of fall, people's thoughts come back to the wolf. "Have you seen the wolf yet this year?" "I wonder if he will be back again." "A friend told me he heard him howling a few nights ago." Such commentary is once again heard every day at trailheads around the lake.

With fall's arrival along the shores of Mendenhall Lake, the contrast between the warm colors of the foliage and the cool-toned glacier beyond can be striking, especially in the morning light. I had not run across our friend the wolf yet, but I knew he was around. His presence was announced by the fresh tracks he had left in the mud close to where a large beaver dam blocked the passage of salmon returning to spawn. The water at the base of the dam was very shallow, providing a good place for a wolf to catch fish. From the extensive array of tracks running back and forth in the silt, on both sides of the creek, and the discarded lower jaw of a male silver salmon lying next to a grassy area matted down along the shore, I could see he had been successful on at least one fishing foray! As I walked the lake's shoreline, checking the various scent posts I knew he used, I found fresh tracks

pressed into the wet sand there as well. He was around, but that day I could find only signs of his passing.

A few days later, on a cloudy afternoon, I decided to walk the West Glacier Trail to scout the area. The water level in the lake was down a bit, making it easier to walk the shoreline, so when the sun started to break through the overcast sky, I moved down from the trail onto the beach and continued to where a steep rocky point makes further travel more difficult. Turning up a spur, I hiked through the forest back up to the West Glacier Trail, and then back toward my truck.

As I loaded my pack into the back of the truck, the howl of a wolf broke the still, heavy, moist air. Somewhere back in the forest, not far away, a lone wolf was announcing his desire for companionship. Having learned to recognize the cadences of his particular howl, I knew Romeo had returned.

It had now been almost three weeks since the

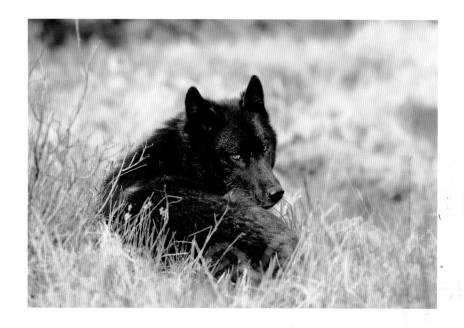

evening I heard that howl. Snow had been falling intermittently for nearly a week, and it was starting to get fairly deep in places. Finally I could justify breaking away for some time out of the office. Grabbing my snowshoes and heading out the door, I went in search of the wolf on the west side of the lake. Approaching the parking area, I could see his

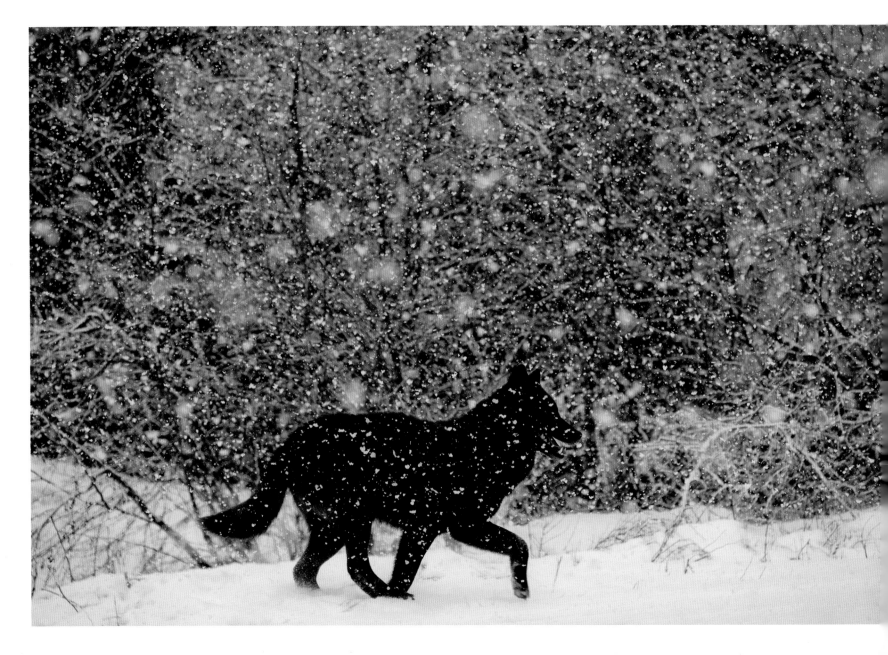

tracks in the snow by the side of the road, and as I began to hike down the trail, I crossed more tracks coming down off the mountain. From their number, it was obvious he had been using the area heavily, finding it appealing for a number of reasons.

He could sit up in the trees above the trail and the parking site, unseen by anyone, until he wanted his presence known. Then when he wanted to play or hunt, he could move quickly down to the main trail or lakeshore in a matter of seconds. Hare, porcupine, and a few salmon were around to feed on. He had been tending to use the packed trails to get around more easily through the deepening snow, and, when out on the lake, he usually took advantage of the packed Nordic ski and skate trail, rather than break his own trail through even deeper snow. Had he become lazy in his old age, or maybe just a little smarter?

A few weeks later, a friend spotted a pack of mostly gray wolves traveling along the northern shoreline of the lake, an unusual event for the area. Talk of another single wolf was beginning to circulate about the same time. I had not seen either, but one afternoon when I was over on the southwest side, relaxing and eating a snack, some skiers with dogs came along the packed trail, with Romeo following behind. He came down the shoreline, and stopped when he saw me sitting in the snow. I took a few photos and then ran out of space on the memory card. While I was busy changing the card, not really paying much attention to anything else, an unfamiliar howl echoed across the ice. It did not sound like Romeo, and when I looked up, he was just sitting there like nothing had happened. As I watched him, the howl came again, reverberating off the mountainside. Romeo glanced over in the direction of the call but didn't answer.

So, there *was* another wolf! It seemed strange that Romeo did not respond. Eventually he got up and continued along the ski trail on the lake. Why

had he not gone over to visit with the other wolf that was obviously calling to him? Was he playing hard to get, or what? Eventually Romeo disappeared into the trees on the far side of the lake, and I went home.

Snow fell hard for the next few nights, and when it stopped, a fresh new winter wonderland awaited. I grabbed my snowshoes and headed out, first going down a short side trail, and then through the forested hillside on the flank of Mount McGinnis, before finally reaching Montana Creek Road. I had not seen anything but tracks, when suddenly Romeo materialized at the edge of a snow-covered meadow, very close to the rifle range, which made me a bit apprehensive. Taking the opportunity to snap a few photos of him emerging from the forest into the open and across the deep snow, I next headed up the road to where it dead-ended at an old bridge. My hope was that Romeo would follow along behind as we started up the trail, thus eventually drawing him away from the danger of being so close to a place where his life could be taken, simply with the excuse that someone perceived his presence as a threat to their safety. He did follow along for a few minutes but then disappeared.

For years, when salmon were running in Montana Creek in the fall, I had occasionally seen wolf tracks along some of the sandy gravel bars. The past two years I had spotted Romeo working that area, but I had never seen him up that way in deep winter. I was not comfortable with the idea that he was so close to people with guns, but there really was nothing I could do about it. He was a wild wolf and could do what he wished. I hoped he would make smart decisions.

A few weeks later, during a morning hike toward the face of the glacier, I spotted a dark object moving down the rocky ridge of bedrock that runs down toward the lake from the ridge above. By the

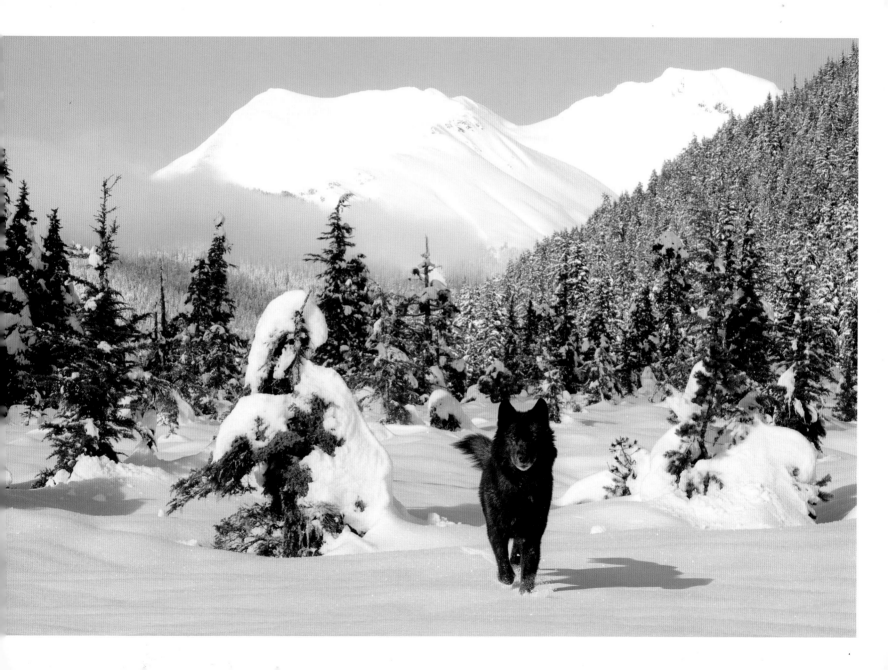

time I could get my binoculars out and up to my eyes, whatever it was had disappeared.

That quick glimpse had not provided enough information for me to tell if it was a dog, a human, or a wolf. I plodded along on my snowshoes, breaking trail across the lake through the deep snow. The calories being burned in this effort warmed me to the point that I needed to shed a layer or two. Stopping to remove my jacket and fasten it to the outside of my pack, I looked up to get my bearings, and there it was again, much closer and farther down the ridge. It was definitely a wolf—the silhouette was unmistakable. As I watched, he came down the ridge and sat in the snow above the lake, looking out over his kingdom. I wished I were a lot closer, because he was still too far away, even for a decent wide-angled shot. I could tell the subject was a wolf, but the camera would have left such interpretation to the viewer at that point!

When I'd approached to within about 200 yards, he got up and went back over the rocky point, disappearing into a white void. I still had hope. I was making the first tracks across the lake, and this meant no one else was out and about which reduced the chance that someone else might spook him or lure him away with their dogs. I decided to head out toward the face, where the glacier met the lake in those towering columns of ice known as seracs. Romeo suddenly appeared, rounding the corner of a huge iceberg frozen on the surface, and was walking across in front of the glacier. Even the most powerful telephoto lens I had in my pack was not enough to get the scene framed as I wished. As my frustration began to mount, Romeo abruptly sat down in the snow, relaxing in the morning sun, giving me time to approach a bit closer. Back toward the visitor center some dogs started barking, catching his attention. He stood up, barked once, and immediately let

loose a resounding howl. That was my cue to make the best of the moment, because it would soon be gone. He howled once more, and I exposed as many frames as I could in those few short seconds. Then he turned and loped off in the direction of Nugget Creek Falls towards his beckoning cousins, a troop of three disparate dogs. Sometimes it was hard not to feel a bit like the proverbial wallflower no one wanted to dance with!

Fall in southeast Alaska doesn't bring the bright colors seen in our northeastern states, but its often understated appearance is just as welcome. A musky scent makes itself prominent alongside the crisp, clean, and more acidic smell of the spruce and hemlock. Devil's club fades from green to yellow, brightening the forests' undergrowth, and streaks of gold appear wherever willow and cottonwood grow along the region's rivers, streams, and lakeshores. An aura of urgency seems to take over the lives of those who must prepare for the long

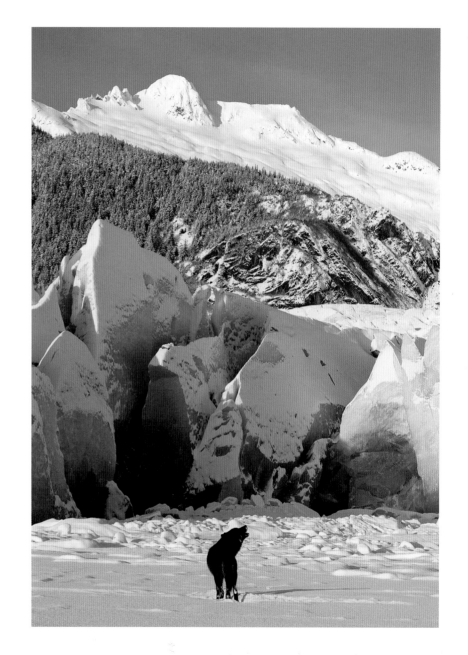

winter. Their activities enliven the forest as they scurry about digging dens, catching food supplies, and making preparations for the deep snow that will soon carpet the landscape.

As the 2009 fall season got going around Juneau, people began to watch for the appearance of the black wolf. Would Romeo appear along the shorelines of Mendenhall Lake, as he usually did every September? During an afternoon hike in late August, I had seen what might have been his tracks along the banks of Montana Creek, but had not actually spotted him. A friend had seen him a few times and reported that he was looking healthy, even a bit on the heavy side for a wolf. There must have been a good run of salmon! His coat was glossy and he obviously had not been missing any meals.

By the middle of September he had vanished. There were no fresh tracks, no reports or sightings, no howls accompanying the fading light as dusk turned to night. People kept expecting him to show up. He had become a reliable seasonal fixture and attraction, for residents and visitors alike. But there were no sightings at all. People began to speculate that maybe he had finally found a mate and they had formed their own pack. Others said they thought they had seen him out the road by Eagle River, and still others reported possible sightings over on Douglas Island. I hoped at least a few of these reports were true, but based on a six-year history of repetitive behavior, I suspected that another fate had befallen him. Even if he had found a mate, the timing would not have allowed for any pups, so the strong bond that that event forges would not have cemented their relationship enough to keep him from venturing down to the lake at least occasionally. And those who had seen him in September had not seen him with another wolf. He had been alone.

Following an investigation by some local residents, it was discovered that two men, one local

and another from out of state, illegally shot Romeo in mid-September with a small-caliber rifle or pistol. Hunting wolves in Alaska is legal, but the area where he was shot was closed to hunting. The hunters clearly thought the use of a small-caliber gun would be less obvious, and made the kill in a location where rifle and pistol fire was commonly heard coming from one of two different firearms ranges. Both were within a mile of the site, so the gunfire would be less suspicious. The group Friends of Romeo was instrumental in pursuing the investigation and ultimately in the arrest of the two individuals involved. In addition to the illegal killing of a wolf within the closed area, these two men were also charged with the illegal baiting of two black bears, and taking game by unlawful methods. The authorities are currently saying they may or may not attempt to confirm that the black wolf taken by these two men was Romeo. The two claim that it was not. But of course identification of the hide that the authorities have in their possession would be a simple matter for a number of individuals, and the fact that Romeo disappeared when he did correlates with the timing of the shooting. Because there are no circumstances under which Romeo would have abandoned his previous behavior so abruptly, other than his death, not many who knew him well have any doubts that his passing was caused by a natural or accidental death.

Evidence has also been brought to light indicating that these men knew exactly which wolf they were after, and made a point of pursuing Romeo because he was a large male that would not try to avoid them. If these men are found guilty, the charges could lead to fines of up to $10,000 and a year in jail. However, because they are class A misdemeanors, they could also amount to nothing more than fines of $1,200 for the bears and $500 for the wolf. The repercussions of this incident are not only unfortunate for Romeo and for all those

who followed his life, they place a dark shadow over sport hunting itself, which will not do the responsible, law-abiding hunting public any favors.

Interestingly, for those of us who see our species as more aggressive than the wolf, the individual who shot Romeo said in his testimony that he did so not because his objective was to kill a wolf, but because (to use his own words) "it was instinctive," inferring that he had no control over his actions and did not think for even a second what the consequences might be when he pulled the trigger. Would you want to cross paths with someone like that, armed, and out walking on your favorite trail?

The difference between humans and other species is that we are supposed to be able to regulate our actions, based on thought and consideration for their results. For a human to react without consideration is less honorable than any action an animal, even a predator, commits to survive.

## BY WAY OF A LAMENT

The day I knew for certain that Romeo had been so needlessly slaughtered, I sat at home and wondered what I would have said at his funeral, if wolves had such things. Above all, I felt shame for our species and imagined that familiar look on Romeo's face when confronted by an aggressive dog that didn't wish to play, and was fruitlessly attempting to assert a dominance that didn't exist.

Greed and egotistical satisfaction are the reasons he is no longer with us. Only we humans kill to satisfy our ego, so we can brag about our exploits to others.

Predators kill to survive. They never take a life because they think it would be cool to have a trophy mount or rug they can brag about to their friends. A wolf that kills prey to survive not only provides for its own survival, it helps the species it preys upon to be stronger as well, by removing

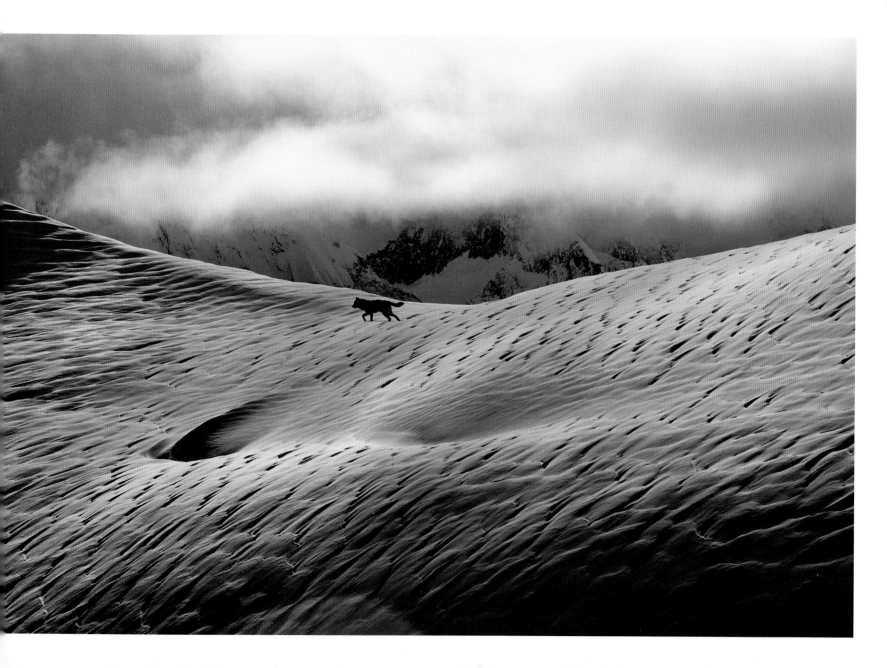

genetically weaker individuals from the population. A person who kills an animal purely for the fun of it does nothing but destroy a life.

Ever since I was a child, wolves have held more mystery for me, than they have been the object of any hate or fear. I grew to see the wolf as a part of the wilderness I loved. They were not given the opportunity to exist anywhere else. I honored and respected them, and held them in high esteem as symbols of wild nature, where, when I was wandering the woodlands and fishing the creeks and streams around my home, I felt the most alive and the most in touch with my soul. Seeing or even just hearing a wolf howl would have been the ultimate experience, but that did not happen until I'd left those eastern woodlands and made my home in those of the Pacific Northwest, many years later.

A peak wilderness experience that I will always treasure occurred one night while camped in the wilderness of British Columbia. Sitting around a campfire, my buddy pulled out his flute and began to play some Jethro Tull. The sound of the aggressive melodies echoing in the crisp air brought a strange but intriguing element to the chill of the night.

After a few songs, he slipped the instrument back into its velvet bag, saying he would rather listen to the wind in the trees and the stillness than disrupt it with his flute. Soaking up the wild atmosphere surrounding us, we laid back against our packs and started to pick out various constellations in the star-crowded sky overhead. My friend reached for a pot of tea, still simmering on the glowing coals that was once our campfire, just as a long reverberating howl echoed through night air. Then a second and a third howl echoed off the surrounding peaks, and within seconds a chorus of howls broke out, followed abruptly by absolute silence. In an attempt to get them to answer, my friend pulled his flute out again, lifted it to his lips,

and played a note as near to a howl as the instrument could produce. No response was given. He tried again. Nothing. We stoked the fire and brought the kettle to a boil once again, probably satisfying our need for the warmth and protection of the flames, as much as any need for more tea!

Lifting the pot to fill our cups, a ghostly shadow darted among the trees, just beyond the light cast by our small fire. I replaced the kettle slowly as my buddy made a sign to freeze. As our eyes adjusted to the shadows of the night, shiny eyes and wet noses seemed to blink on and off like huge fireflies. Here, there, all around. And then they were gone.

My second experience with wolves came a few years later when something—I was not sure exactly what—woke me in the night. Curled in my warm sleeping bag, on a camping trip into Canada's Yukon, I hesitated to venture out, choosing to lie there and listen instead. Something was moving around outside our small tent. It was more a

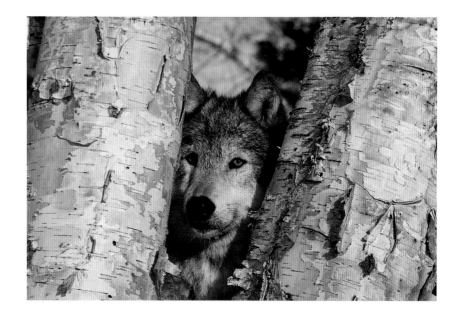

feeling, than a certainty of anything, yet I was sure there was something out there. Suddenly I heard the line that anchored our small nylon tent twang, followed by the definite sound of feet scurrying about, and of something breathing.

The temptation by then was too overwhelming to resist, and I was not going to get back to sleep anytime soon, so while my three companions were still sleeping, I very slowly and carefully moved the tent flap aside, just enough to see two large yellow

eyes peering intently into mine from less than 10 feet away! In a flash, they whirled around, and the animal leaped and disappeared into the murky gray light of predawn. Just seconds later it was so quiet I started to wonder exactly what had happened. A loon called on the lake out beyond camp. Later I could see on the dusty ground the faint but definite impressions of some very large canids—wolves, to be exact! I had not been dreaming.

So, just how dangerous are wolves? There are only two documented cases of a wolf or wolves attacking and killing a human in North America, ever. Neither event was actually witnessed, so we will never know exactly how or why either occurred. One was reported in Canada and the other in Alaska. Many, many more people die from attacks by other wild animals, reptiles, or insects, such as bears, cougars, snakes, spiders, and sharks. More people are killed in attacks by domesticated animals, such as cattle, horses,

and even dogs. The wild ungulate species that wolves feed on kill many more people every year than wolves ever have. Buffalo, moose, elk, and even deer have killed people when provoked in defense of their young, when wounded by hunters, and indirectly in automobile accidents. But then, lest we miss the point, our species has been known on too many occasions to act without much forethought. Perhaps even more tragic is the prejudice that evolves from rumor rather than fact, and influences our beliefs and actions to no good purpose.

The wolf, in fact, is near the bottom of the list of dangerous animals—the very bottom. Let me say that after spending many years shedding the cultural misconceptions I had accumulated concerning wild animals, I had considered myself relatively free of any prejudice.

But one day, Romeo taught me that I was not. He had approached and lay down on a snowdrift

nearby, and seemed to go to sleep. He was quite close and presented one of the best photo opportunities I had experienced to date. It wasn't long before I needed another memory card for my camera. But this presented a challenge. The cards were in my pack, which lay in the snow about 20 feet behind me. I felt I could not get up to get them without creating a disturbance that he might find threatening, resulting in him moving away.

So I thought it best to crawl on my belly back to my pack and see if that would disturb him or not. To do so, I had to turn my back on this large wolf, and even though I felt certain he would cause me no harm, I hesitated. It was clear that somewhere deep down I still possessed some of what had been drilled into me ever since I had been read those bedtime stories, so long ago. Their influence still lay way down there somewhere in my subconscious. Our fear of wolves is more a human social problem, than a physical one presented by these

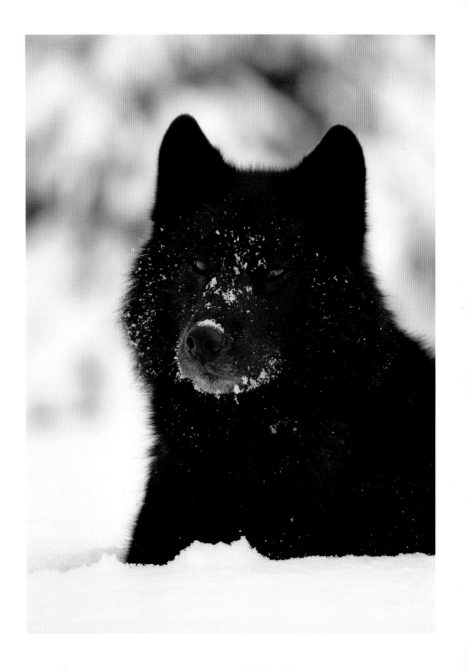

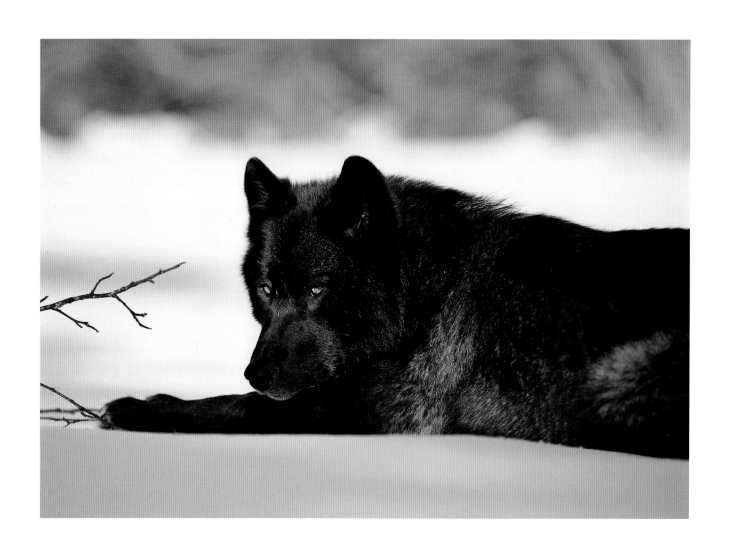

natural predators. The problem is our own lack of any perspective, of any well-informed idea how we as humans fit in nature.

Over time my experiences with the black wolf known as Romeo finally helped me shed the cultural conditioning of my early childhood–but it did take time. I still respect wolves for the wild predators that they are and for their ability to take my life if they choose to. And I will always choose caution, first and last. But I do not see them as creatures that are waiting for me to put myself in a situation in which they could take advantage of me as prey. Instead, I see them as creatures with just as much–if not more–right to the resources that our wild lands can provide for food and for shelter. I see them as creatures that are as essential as any to our natural ecosystems, and ones that are worth making sacrifices for to ensure our coexistence.

When I next meet another lone wolf, or even a pack, I certainly will not attribute to it the same personal traits or behavior I did with Romeo, because the events of that animal's life will have been significantly different. It will thus be a different animal. There will be no history with which to gauge any possible behavior. It will be neither vicious nor harmless. No prejudice will color my interpretation of the fact that a wolf is certainly capable of taking a human life. But capacity for action does not determine reaction. The fact remains, that wolves choose to avoid conflict with humans, as they do among themselves.

In Alaska there is very often little transition between wild lands and ones settled by people. Thousands of square miles of wilderness abut our backyards, so the opportunity for predators to suddenly appear is much greater than in more settled areas. The habitat supports large numbers of these predators (bears and wolves), so if the environmental conditions place stress on these

species, they can be in town looking for an easy meal, without much effort.

And it happens every year. But bears and garbage are always the issue. In more than thirty years I have never heard of a wolf-garbage problem. The bear-garbage problem is just a part of life, and we lock up garbage or place it in bearproof containers. Bears have even been known to break into garages and once in a while even our homes, looking for a free meal. Cubs live with their mothers for about three years, and if their mothers are "garbage bears," then the cubs learn the same habits.

Responsible citizens reduce this risk by following the correct procedures for storing their refuse. Sometimes wildlife control agents need to capture and relocate a bear that has become a repeat offender, or they make attempts to recondition the animal, hoping that it will avoid future contact.

How would we respond if a wolf, or pack of wolves, started walking our streets, knocking over garbage cans, or getting into Dumpsters? I don't think we'd have the same tolerance for the wolf as we do the bear. It is not simply a question of perceived danger.

Being at the top of the food chain, wolves are apex predators that play vital roles within our natural systems, ones that we humans cannot replace. Because they concentrate their efforts on capturing physically compromised prey, they actually increase the health of the animal populations they prey upon, by slowly eliminating weaker genetic strains, resulting not just in survival but also healthy reproduction.

Through these actions wolves also make use of animals that would die shortly anyway, reducing the need to remove healthy animals from any specific prey population. Of course, they do take some healthy individuals as well, but in the main they concentrate on the weak and injured. The negative effects are balanced by the positive.

When humans hunt for sport or food, they concentrate only on the strong and healthy animals in a population: robust healthy males, and sometimes healthy females and potential breeders. We contribute much less in the long run to the animals we prey upon than the wolf, and in our attempts to take their place, we damage the long-run health of our deer, elk, moose, and caribou populations.

In his wonderful book *A Sand County Almanac*, Aldo Leopold wrote in the mid-twentieth century about what he called the "feelings of the times" in regard to wolves:

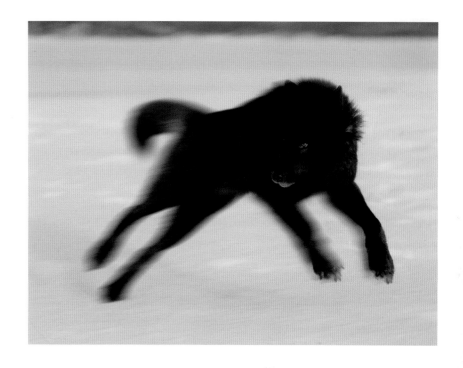

> We were eating lunch on a high rimrock, at the foot of which a turbulent river elbowed its way. We saw what we thought was a doe fording the torrent, her breast awash in white water. When she climbed the bank toward us and shook out her tail, we realized our error: it was a wolf. A half-dozen others, evidently grown pups, sprang from the willows and all joined in a welcoming melee of wagging tails and playful maulings. What was literally a pile of wolves writhed and tumbled in the center of an open flat at the foot of our rimrock.
>
> In those days we had never heard of passing up a chance to kill a wolf. In

a second we were pumping lead into the pack, but with more excitement than accuracy; how to aim a steep downhill shot is always confusing. When our rifles were empty, the old wolf was down, and a pup was dragging a leg into impassable side-rocks.

We reached the old wolf in time to watch a fierce green fire dying in her eyes. I realized then, and have known ever since, that there was something new to me in those eyes—something known only to her and to the mountain. I was young then, and full of trigger-itch; I thought that because fewer wolves meant more deer, that no wolves would mean hunters' paradise. But after seeing the green fire die, I sensed that neither the wolf nor the mountain agreed with such a view.

Leopold realized the value that wolves play in our natural systems. Even if it was in a subconscious vein at the time, it was part of the force that caused him to examine the current management practices that ruled within wildlife and wild lands agencies. Further on he states:

> Since then I have lived to see state after state extirpate its wolves. I have watched the face of many a newly wolfless mountain, and seen the south-facing slopes wrinkle with a maze of new deer trails. I have seen every edible bush and seedling browsed, first to anemic desuetude, and then to death. I have seen every edible tree defoliated to the height of a saddlehorn. Such a mountain looks as if someone had given God a new pruning shears, and forbidden Him all other exercise. In the end the starved bones of the

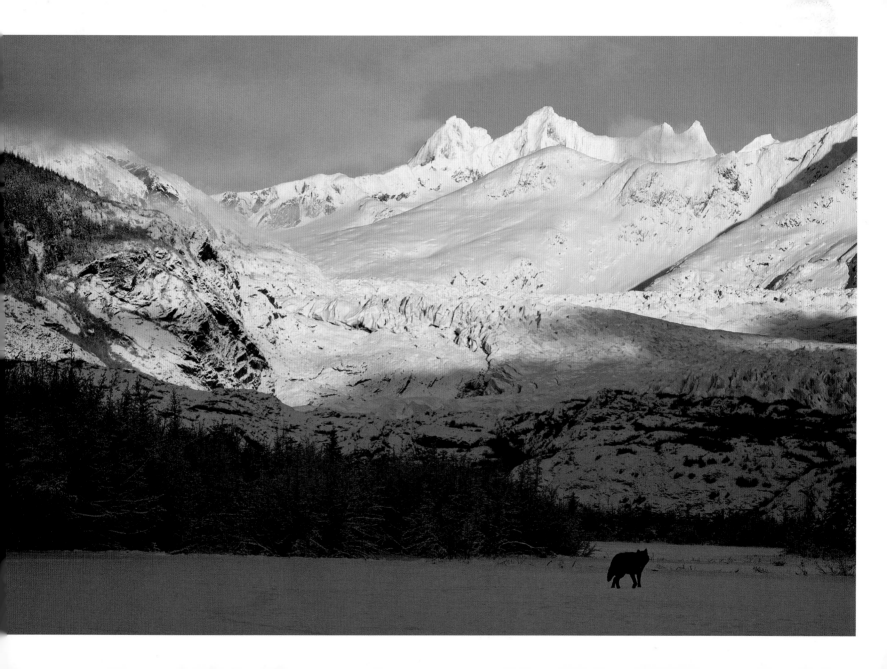

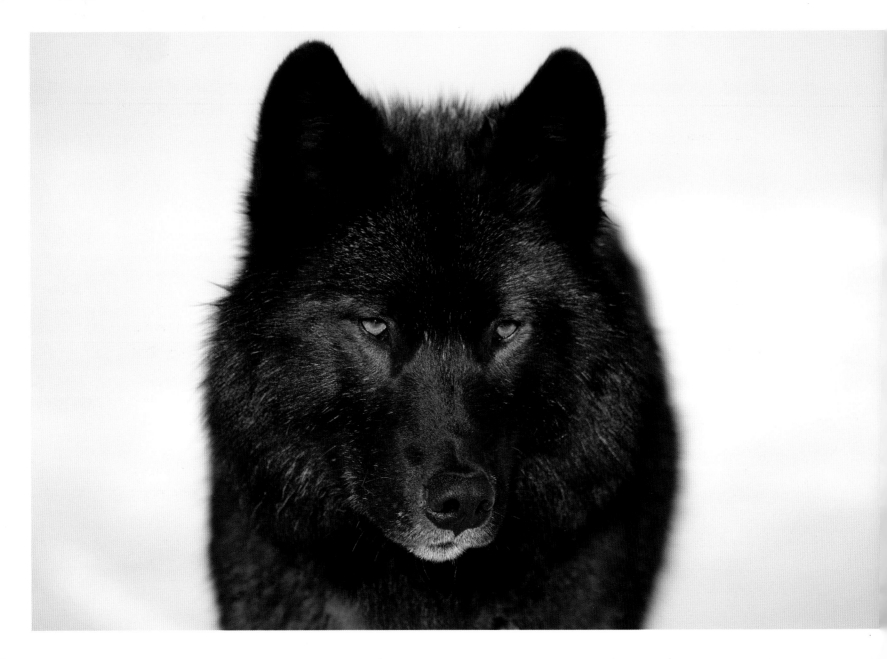

hoped-for deer herd, dead of its own too-much, bleach with the bones of the dead sage, or molder under the high-lined junipers.

Leopold for the most part wrote about the southwest in the early 1900s, but his eloquence extends beyond that region and time, to include anywhere that predators have been removed from natural systems in an effort to reduce competition with humans for the same resources.

Is there a lesson to be learned from Romeo's tragic end?

The people of Juneau who followed Romeo's exploits, caught glimpses of him while out skiing or hiking or walking their dogs, miss his presence at the lake as they would a much-loved character. Others who never even saw him miss him too, as they found a sense of comfort in his existence, a sign that the entire world has not yet been tamed. This is magnified by the fact that his end was not a natural one.

Romeo is gone, but his spirit will survive for much longer, and so will the lessons he taught us. Many learned that sacrifice and tolerance can result in new experiences and a more complete understanding of the world around us. This past winter, a few more wolves have been seen in the Mendenhall area. Public acceptance and tolerance for these animals is much greater than it would have been ten years ago. No one suggested that they should be shot or relocated, as likely would have been the case back then. Romeo has taught us that we can live with wolves. That respect is the key to coexistence, not fear.

Romeo taught us that wolves aren't the vicious bloodthirsty beasts they have often been made out to be, waiting in the shadows of our imaginations to devour our pets, livestock, or children.

It is very unlikely I will meet another wolf like

Romeo, but I know I will always catch a glimpse of his shadow fading into the brush as I round a corner in a trail, or hear the howl of a wolf dissolving in the breeze off the glacier. Whenever I walk through the old haunts he claimed, visions of the times we spent together will float just under the surface of my subconscious, breaking through every now and then, as I see tracks or signs of other wolves. Romeo's personality and spirit will live on, wandering the shorelines and forested trails surrounding Mendenhall Lake for as long as those who knew him and his story persist.

Even though we mourn his passing, we celebrate the joy and wonder that accompanied his existence. Romeo brought a special character to the area, and with that a growing respect and understanding for wolves in general.

The howl of the wolf has often been described as the call of the wild, and if Romeo can teach us anything, let it be that we should answer that call, by becoming more tolerant, giving all wild animal species a chance to belong and a habitat within which to make productive lives and be respected as members in the community of life.

*Mendenhall Lake, Juneau, Tongass National Forest, Alaska; February 2008*

Though it is nearly 8:00 A.M., the sun has yet to rise above the horizon. Because it is midwinter, it won't go much higher once it does, but the darkness of the night has been diluted enough for me to find my way along the small trail leading up the river to the lake above.

The quiet whisper of ice crystals driven across the frozen surface of the river on a gentle breeze from the glacier above is the only sound disturbing the silence. For the last week there has been very little wind, and the temperature has not risen above 15 degrees: perfect conditions for the formation of

hoarfrost along shorelines of the river, where delicate crystals of ice grow into petal-like rosettes. As I make my way along the trail, trying to avoid disturbing the fragile beauty of these icy creations, a faint, almost imperceptible shadow glides over the snow catching my attention. A raven flies overhead on an early errand turning its head to check on the man-creature below struggling through the snow on the uneven terrain.

As I reach the frozen expanse of the lake, the wind picks up a bit. A few hundred yards down the shoreline, a constellation of footprints in the snow reveals that Romeo found a willing playmate the previous afternoon. Instead of the tracks having crisp edges, they are softened by tiny crystals of rime that formed over the cold night. He could be anywhere within a 4- or 5-mile radius by now, as close as the brush line a few hundred feet beyond, or as far away as the northwest side of the lake, deep in the snowy forest along its shoreline. Even

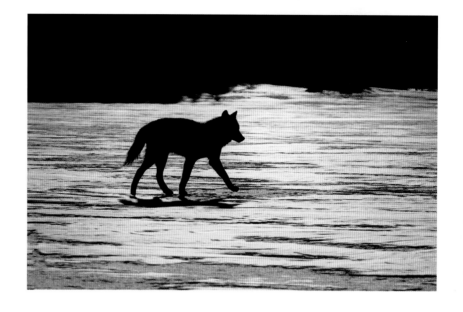

if I fail to find Romeo, a gorgeous winter morning is about to dawn. As I continue to wander down the shoreline, my thoughts turn to wolves in general. Why does the presence of a creature such as a wolf force us to ask ourselves what it is we seek in the wilderness, where the extremes of life have only two results? What is the value of such introspection? Does mankind still have a place on this planet—one where we can coexist with the natural order?

Why am I pondering such philosophical questions when I am supposed to be making some photographs, trudging along on a pair of well-worn snowshoes held together with duct tape and slip ties?

Rather than having to endure the floundering embarrassment of needing to recover from an ungainly face-plant in deep snow, I focus my attention back to negotiating the steep rise in the drift just inches in front of my techno-clad feet, even if the only witness is that raven who laughed at me earlier! Making it to the top of the slope without mishap, I naturally look up from my feet to get my bearings. With a mixture of calm and curiosity, two yellow eyes look over the top of a small spruce and right through me, seemingly into a world I can only hope to see or interpret. The tables have been turned. Instead of me looking for the wolf, the wolf is watching me.

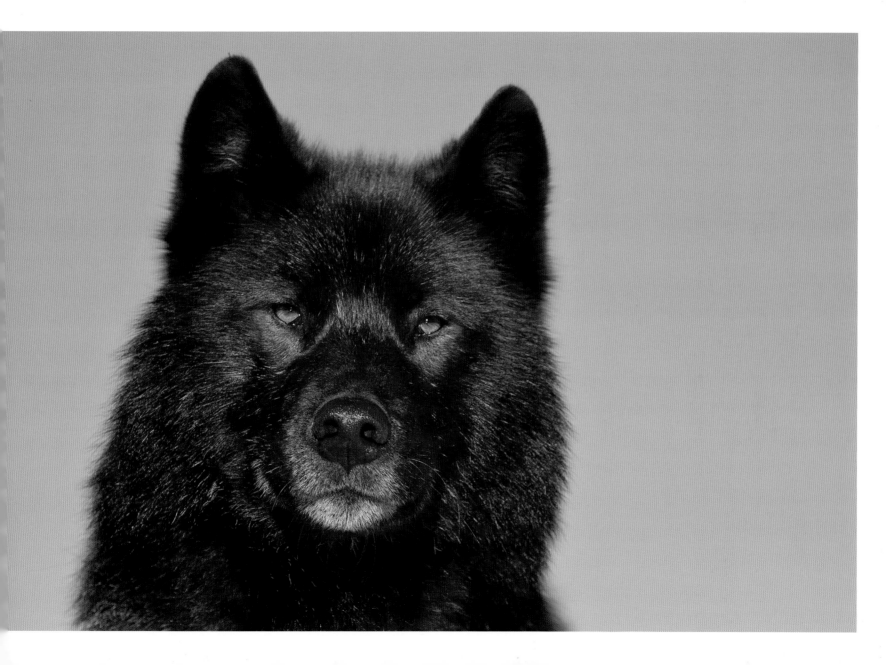

**ACKNOWLEDGMENTS** Thanks go first to my mother, who always encouraged me to pursue my dreams by suggesting that you must at least make an effort to do so, because you don't want to end up regretting you hadn't when it is too late. That advice got me started at Oregon State University, where I met Harrison Branch, my photography professor. He stressed above all else the need to discover what makes us want to make photographs in the first place—then work to incorporate that into our images. That advice has shaped my work as a photographer ever since, and I thank him.

Just about any subject in the natural world can provide inspiration: a beautiful landscape, or the interplay of light and shadow and how it both reveals and conceals elements within the landscape. It's the wild creatures of that landscape that I find most magnetic. They can also be the most frustrating. You can't tell them what to do, where to go, or how to act. The light can be wonderful, but they may choose to sit in the shadows or simply get up and leave. You count yourself lucky if they accept your presence and go about their lives as if you aren't there. I am grateful to Romeo, my inspiration, for allowing me the opportunity to record a small part of the time he spent living his life on the edge of our world in the upper Mendenhall Valley.

Friends of Romeo, a local organization led by Harry Robinson that was developed to promote responsible wildlife viewing and management, also deserves our gratitude for the efforts they have made toward helping the public understand how precious an opportunity was presented through Romeo's existence.

And last but not least, thanks to my wife and daughter, who are the most loving and supporting companions anyone could ever hope for. They are the force that draws me back from the wilds to live in the domesticated world where we make our home.